BRUSHES

BRUSHES

A Handbook for Artists and Artisans

Jacques Turner

Design Books

Grateful acknowledgement is made to M. Grumbacher, Inc. and to Isabey/Ouest Pinceaux Fins for permission to reproduce the photographs credited to them.

Printed in the United States of America

Designed by Edith Allard

Library of Congress Cataloging-in-Publication Data
Turner, Jacques, 1940–
 Brushes : a handbook for artists and artisans / Jacques Turner.
 p. cm.
 Includes index.
 ISBN 1-55821-501-8
 1. Artists' brushes—Handbooks, Manuals, etc. 1. Title.
N8543.T8 1992 91-46004
751.3—dc20 CIP

Published by Design Books

Design Books are distributed by
Lyons & Burford, Publishers
31 West 21st Street
New York NY 10010

5 4 3 2

CONTENTS

Preface

Most artists are not fully aware of the influence the quality of their brushes has on the work they do. It is possible to produce fine paintings with paints of poor quality (they are just less permanent), but it is very difficult to obtain good results using badly made brushes. I have met beginners who were convinced that they lacked ability because they were unable to produce certain painting effects, when in reality their failure was the direct result of the inferior brushes they were attempting to use.

Experienced artists sometimes purchase new brands of brushes only to discover that the brushes fail to perform properly. They swear never to buy that brand again without understanding why the brush disappointed them, and return to using their old brushes. Indeed, very little precise information is available about the manufacture, quality, and use of artists' and craftsmen's brushes. Moreover, rules and regulations concerning the labeling and contents of brushes is seriously lacking. This book is an effort to remedy these problems. Based on my experience of over twenty years in the brush-manufacturing industry, it provides comprehensive information for all those who purchase, use, or sell artists' and craftsmen's brushes.

The subject is explored in a simple, logical, straightforward manner: included are numerous illustrations to facilitate understanding. Nonetheless, I strongly recommend that the reader attempt to gain access to a wide variety of brush samples for study. This may involve making regular visits to local art-supply shops that stock a complete selection of artists' brushes.

A Brief History of Brushmaking

Little is known about the beginnings of brushmaking, but it is probable that the first brushes were made with tufts of hair plucked directly from animal skins; these tufts were then tied to the ends of wooden sticks. More sophisticated versions of such brushes were manufactured well into the twentieth century (fig. 1-1). Before brushes were devised, our ancestors may have applied paint with the ends of twigs, and with the tips of feathers.

The first ferrule may have been made by cutting a hollow tube from the base of a large bird feather. Quill brushes are still manufactured in several European countries (fig. 1-2). Metal ferrules began to appear in Europe during the eighteenth century, when brushes began to be produced in factories in an organized manner.

Until the nineteenth century, artists' brushes were usually round, pointed, or oval shaped. Square, flat brushes were introduced as impressionism became popular.

Brushes were entirely handmade until the twentieth century, and the basic methods of manufacture changed very little until recent times. Machines to perform some of the

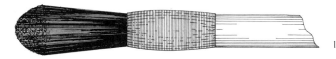

1-1. *Early brush construction.*

1-2. *Quill brush.*

simpler operations were introduced at the turn of the century; however, the tufts of hair inserted into the ferrules continued to be prepared and shaped exclusively by hand.

Brushmakers were trained in an apprentice system, beginning by learning the simpler tasks in the factories. Generally apprentices required about two years to learn to make the lower-quality scholastic-grade brushes and five years to master making top-quality professional-grade artists' brushes.

During the 1950s machines were introduced to produce brush heads for artists' brushes, but they proved suitable only for the manufacture of inexpensive brushes of inferior quality. In the mid-1980s, mechanized brushmaking systems that could produce very acceptable medium-grade brushes were finally perfected. Consumers often cannot distinguish machine-manufactured brushes from handmade ones because they look exactly the same.

England, France, and Germany have benefited from a very long tradition of high-quality brushmaking and today lead the industry in Europe. The raw materials, components, and manufacturing techniques are very similar throughout Europe, although there are very distinct differences in styling that are evident to the trained eye. Artists' brushes are also produced in Italy, Spain, and Eastern Europe, but their quality leaves something to be desired.

American manufacturers employ the same basic methods, materials, and machines that are used in Western Europe. The industry in the United States has been significantly influenced by European brushmakers, many of whom immigrated to North America early in the century.

Artists' brushes are also manufactured extensively in China and Japan. Brushes for the Western market manufactured in the Orient look exactly like those manufactured in the West, to the untrained eye. In reality, the preparation of the raw materials, the manufacturing techniques, and the styling of the brush heads are completely different.

Artists' brushes are distributed by wholesalers and importers through art-supply retail stores and other retailers that have art-materials departments. They are purchased and used by fine artists, graphic artists, hobby painters, sign painters, makeup artists, and other craftspeople, to name but a few. They are used in a wide variety of industrial applications.

Generally speaking, regardless of how brushes will be used, everyone's main objective should be to obtain brushes of the best quality at the lowest price. Hence, it is important to know how to examine and evaluate brushes, to determine the relative merits of those currently on the market.

Brushmaking Techniques

The parts of an artists' brush are illustrated in figure 2-1. Each will be discussed in this chapter.

Hair and Bristles

The most important part of an artists' brush is the tuft of hair that picks up and spreads the paint onto the surface. Most manufacturers therefore select hairs and bristles with great care.

These raw materials are usually of animal origin, taken from the tails or skins of a wide variety of species. By-products of the fur and food industries, they are supplied to the brush industry by merchants who specialize in the collection and preparation of hairs and bristles for brushmaking.

The tails and skins are first washed and shampooed to remove the animal grease and soil that has accumulated on the hairs. They are then set out in the sun to dry, whenever possible. Some of the finer raw materials, such as sable and squirrel tails, are then baked in ovens, to give the hairs the right degree of elasticity.

The hairs are then cut from the tails or skins with scissors and thoroughly combed in both directions to remove any foreign particles or pieces of hide that remain.

They are sorted into batches of equal lengths and tied into bundles, the diameter of which varies according to the amount of hair of a given length that is harvested (fig. 2-2). The natural tips of the hairs must all face in the same direction.

Hair and bristles are sold by weight. Shorter lengths are always more plentiful, making the longer lengths more expensive. For example, kolinsky sable tail hair is available in

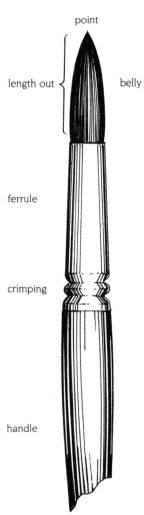

2-1. *Anatomy of a brush*

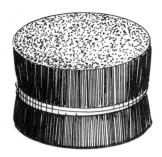

2-2. *Bundle of hair for brushmaking.*

belly

butt

2-3. *Shape of pointed natural hair.*

lengths of from 28 to 70 millimeters (1 1/8 to 2 3/4 inches). At current market prices, 28-millimeter hair sells for about $1,000 per kilogram, while the longest lengths can command as much as $10,000 for the same amount. Consequently, longer, larger brushes cost much more than shorter, smaller brushes.

The preparation of the hairs is extremely important. Good hair can be ruined if improperly dressed.

To ensure quality each manufacturer would ideally dress hair right in its own factory. Unfortunately, most manufacturers are unwilling to go to the trouble and expense associated with an in-house hair-dressing operation. Instead, most manufacturers carefully inspect each delivery of dressed hair to be sure that the shipment is of the origin, quality, and weight that was ordered. The points, or natural tips, of the hairs must remain undamaged and intact. The hairs must not be overwashed or overbaked, or they will be brittle and fragile. Nonetheless, they must be clean, straight, and properly combed, so that they do not stick together when manipulated by brushmakers.

Most pointed natural hairs have a thick midsection, called the *belly*, and a thinner root section, called the *butt* (fig. 2-3).

Since the hairs themselves are pointed, better round soft-hair brushes come to a very fine point when wet. Square brushes come to a fine razor edge. This characteristic is accentuated by the round oval shape given the tufts by the brushmakers, causing the hairs to be staggered (fig. 2-4). This explains the forms of certain tufts when wet (fig. 2-5). Brushes made with cylindrical (nonpointed) hairs will never come to a very fine point or to a razor edge, regardless of the shape given the tufts by the brushmakers (fig. 2-6).

Pointed hairs are usually superior in quality, and more expensive, than cylindrical hairs. The most commonly used conic-shape (pointed) hairs are:

kolinsky sable tail hair
weasel tail (red sable) hair
squirrel tail hair
mongoose hair
badger hair

There are a number of different types, colors, and qualities within each individual group, resulting from variations in the species and the climate where the animal lived.

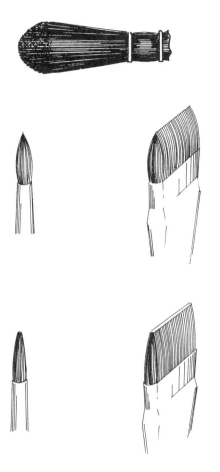

2-4. *Dry round soft-hair brush, showing characteristic staggering of hairs.*

2-5. *Round and flat brushes made with pointed hairs. The hairs come to a fine point or razor edge when wet.*

2-6. *Round and flat brushes made with hairs that are cylindrical, that is, not pointed. Notice that they never achieve a fine point or sharp edge.*

The most common cylindrical hairs are:

ox ear hair
horse-body (pony) hair
goat hair
nylon fibers

Pig bristles (hog hair) are also often employed, but they have a unique shape and are thus classified differently by most manufacturers.

Ferrules

Ferrules, the metal ring that holds the tuft and fastens it to the brush handle, are manufactured in two basic shapes, conic and cylindrical (fig. 2-7). Cone-shape ferrules are generally used for round pointed brushes, and cylindrical ferrules are used for flat brushes.

Both shapes are produced in one of two ways, with or without a seam (fig. 2-8). Seamless ferrules are made with cylindrical tubing of different diameters that is cut into varying lengths. Conic seamless ferrules are produced on machines that compress one end of each tube, transforming the cylinder into a cone. Seamless ferrules are preferable because they last longer. They are often made of brass or copper, which is then polished or nickel-plated for aesthetic reasons. Such ferrules are the most expensive. Seamless ferrules made of aluminum are less costly. Because they are relatively soft, they can be easily damaged or deformed, making them suitable only for scholastic-grade brushes.

Seamed ferrules are made from flat sheets of metal, from which are stamped pieces that are rolled into cylinders or cones (fig. 2-9). The seams can be joined by overlapping, folding, or soldering (fig. 2-10). Soldered seamed ferrules are usually plated afterwards to mask the seam. Seamed ferrules are usually made of aluminum, tin, or nickel-plated tin. Aluminum is best, because tin rusts rapidly. Seamed ferrules are considerably less expensive than seamless ones. They are also of inferior quality, because solvents and thinners used in painting pass through the seams, causing the handles to loosen. This sometimes even dissolves the glue that holds the hairs in the ferrules. Brushes that have seamless ferrules are therefore preferable; however, be aware that there are differences of origin and variations in quality even among these.

For example, sharp, irregular interior edges sometimes result when the metal tubing is cut to the individual ferrule length. These edges can cut into the tufts and damage the hairs. Examine the end of the ferrule from which the hair protrudes to determine if these edges have been eliminated and the ferrule has been properly finished (fig. 2-11).

Finally, for those who are inclined to think that the subject of ferrules is relatively unimportant, it is interesting to note that a good ferrule can easily represent as much as one-third the cost of a medium-price brush.

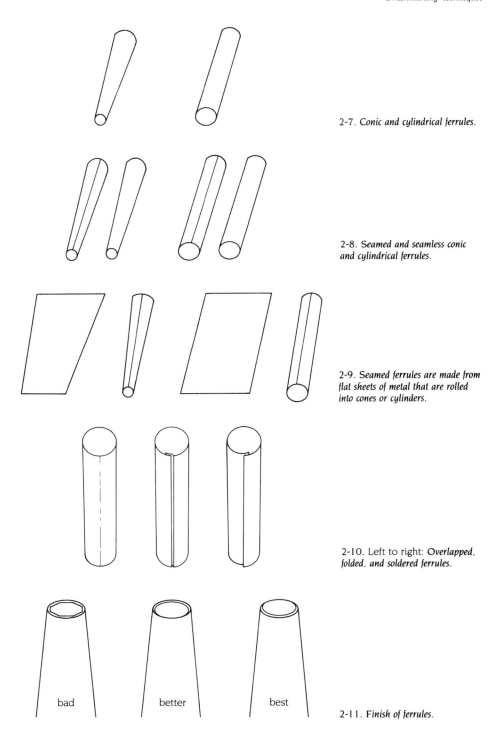

2-7. *Conic and cylindrical ferrules.*

2-8. *Seamed and seamless conic and cylindrical ferrules.*

2-9. *Seamed ferrules are made from flat sheets of metal that are rolled into cones or cylinders.*

2-10. Left to right: *Overlapped, folded, and soldered ferrules.*

bad

better

best

2-11. *Finish of ferrules.*

How Brushes Are Made

Artists' brushes are made to conform to a predetermined set of specifications, individual to each series and size, which tell the brushmaker what raw materials should be used and how they should be put together to produce the desired characteristics and shape. These specs, which can vary considerably from brand to brand, are considered to be trade secrets by many of the better brush manufacturers.

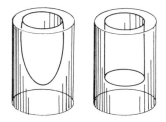

2-12. *Brushmaker's molds.*

The brushmaker begins by going to the stockroom to draw the required hair, all of the same length, and the proper ferrules. He or she then selects a brushmaker's mold—a heavy hollow brass cup into which the hairs are placed, points down—of the right size and shape (fig. 2-12). The bottom of the inside hollow of these molds is rounded for round pointed brushes and flat for square brushes.

The precise amount of hair required to make one brush is placed into the cup, points down. Then it is gently but rapidly tapped on a marble slab until all the hairs fall to the bottom of the mold, thereby forming the desired shape. Before removing the tuft of hair from the cup, the brushmaker wraps a string around the base of the tuft several times and ties a knot if the brush being made is a high-quality round brush.

The cup gives the brush a simple basic shape, which is satisfactory for ordinary scholastic-grade artists' brushes. For finer-quality brushes, however, after removing the tied tuft from the cup, the brushmaker can further accentuate the point and the shape by rolling the tuft between the fingertips, manipulating it in different ways. This is one of the most important procedures in brushmaking; such individual attention is one of the main advantages of handmade brushes.

Flat square brushes and all scholastic-grade brushes are not tied. Instead, a string is simply wrapped around the tuft several times without tying a knot. The tuft is then inserted into the ferrule and adjusted to produce the right length out; the string is then removed. The string helps to ensure that the tuft retains its shape while being passed through the ferrule.

2-13. *Stacking is the technique used to produce arrow-shaped tufts like this one.*

An entirely different technique, called *stacking*, is used to make brushes that have very long, narrow arrow-shaped points, as in figure 2-13. Unlike the aforementioned methods, which require bundles of hair all of the same length, stacking involves bundles containing as many as five different hair lengths. The brushmaker uses cups with flat-bottom molds, and the hairs are inserted with their points facing up, not down. After the precise amount of hair needed to make

one brush is inserted into the cup, butts down, it is tapped on a marble slab to force all the hairs to fall to the bottom of the mold. String is then wrapped around the tuft and tied. When the hairs are spread out, tufts constructed in this manner appear to be square at the tips, instead of oval, as other pointed brushes are (fig. 2-14).

The objective of every system is to produce the finished shape without ever cutting the points of the hairs, which must be preserved. Unfortunately, many manufacturers prefer to ignore this rule in order to reduce production costs. This is particularly true with regard to square brushes, because the damage caused by cutting the tips is less easily seen.

Once formed and tied, however, the entire tuft can be cut at the base without any undesirable consequences. Indeed, such cutting is often necessary to leave enough room in the ferrule for the handle.

Before a handle is inserted, liquid glue is injected into the ferrule through the rear. The finished brush head is then left to dry, suspended in a rack, tuft hanging down. No standard glue is used; formulas vary from manufacturer to manufacturer. However, it is essential that the hairs bond firmly to the metal wall of the ferrule. Furthermore, the glue should be of a type not easily dissolved by the solvents and thinners used in painting.

Handles are then inserted into the ferrules and securely fastened by crimping each ferrule around the handle. Before crimping, some manufacturers glue the handle into the ferrule, which makes a stronger brush.

The completed brushes are then passed to the finishing department, where they are inspected for defects. The tufts are usually sized with a solution of gum arabic and shaped. When they are dry, a protective plastic cap is placed around each brush head; the gum arabic holds the hair in place so the tufts are not damaged during this process.

2-14. *Stacking produces a square-tipped tuft, rather than an oval tuft.*

Preparing Natural Hairs for Tufts

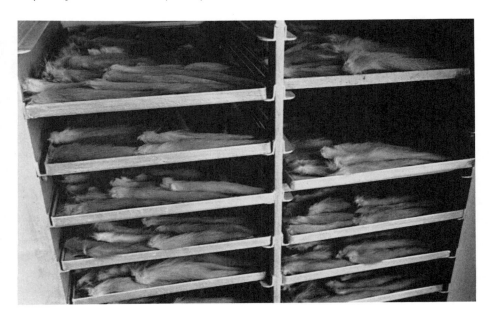

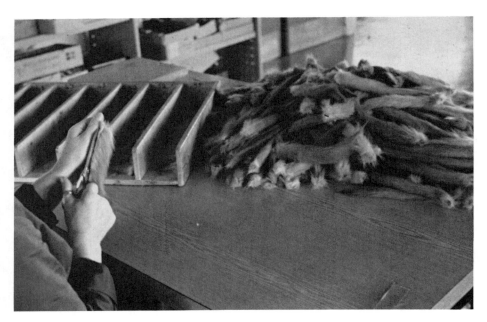

Top: After being washed and dried, the kolinsky tails are baked to improve their elasticity. *Bottom*: The hairs are then cut from the tails.

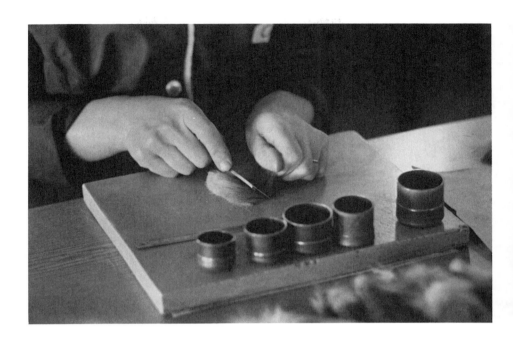

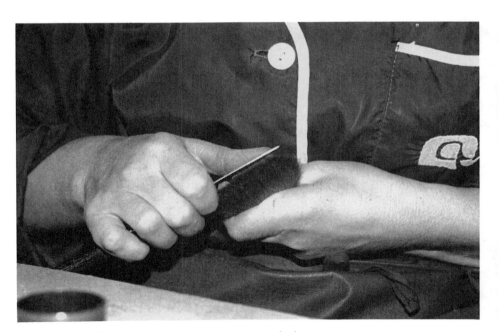

The cut hairs are thoroughly combed to remove any attached debris.

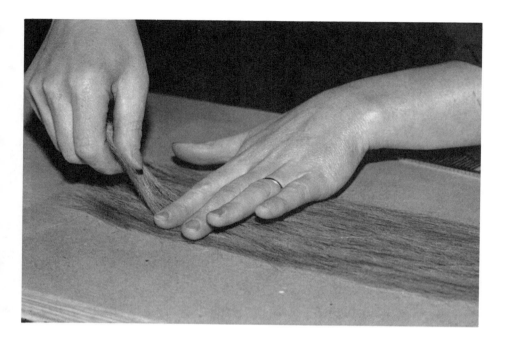

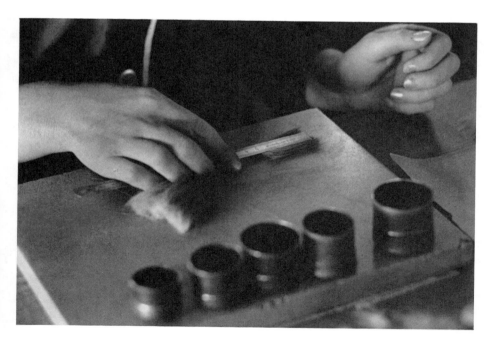

The hairs are sorted by length.

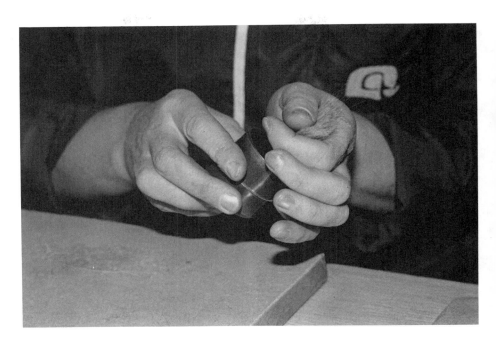

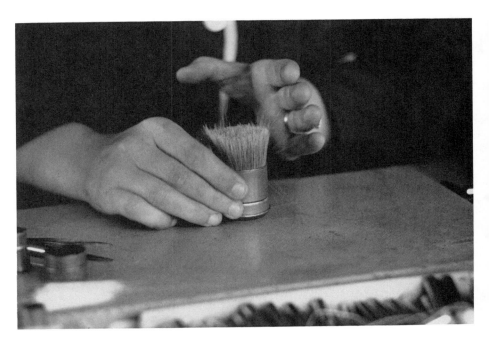

The hair is then bundled.

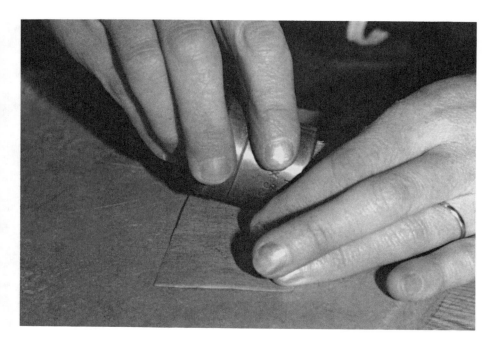

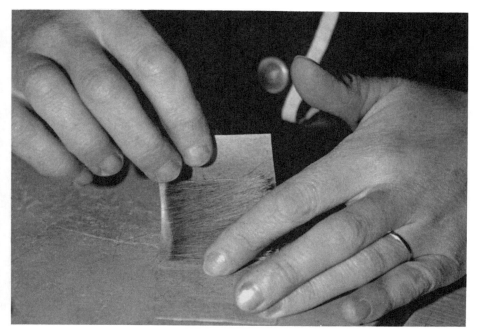

Top, bottom, and opposite, top: The bundled hair is wrapped and tied with string.

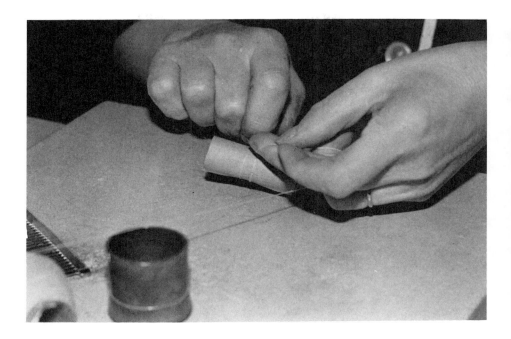

Making a Tuft

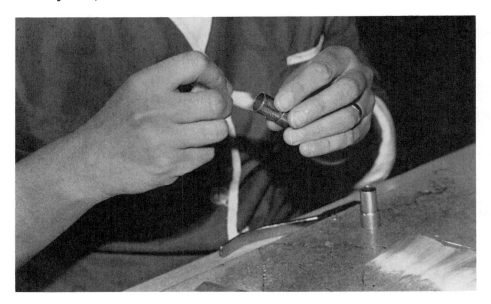

The hair for one tuft is placed, points down, in a brushmaker's mold.

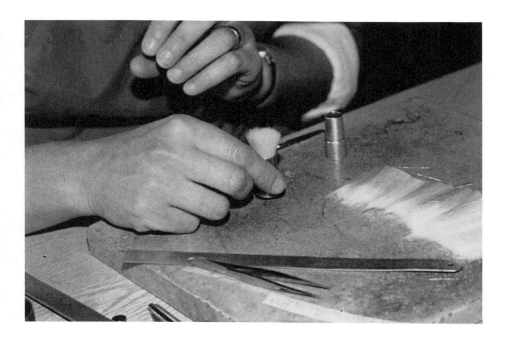

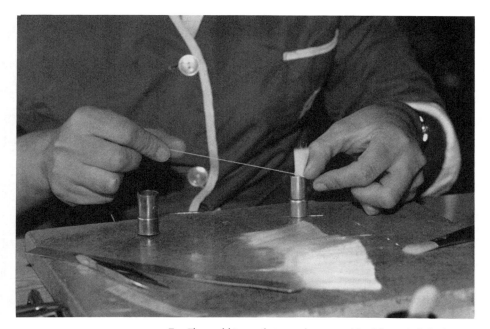

Top: The mold is gently tapped on a marble slab until all the hairs reach the bottom of the mold. *Bottom*: String is wrapped and tied around the hairs at the tuft's base.

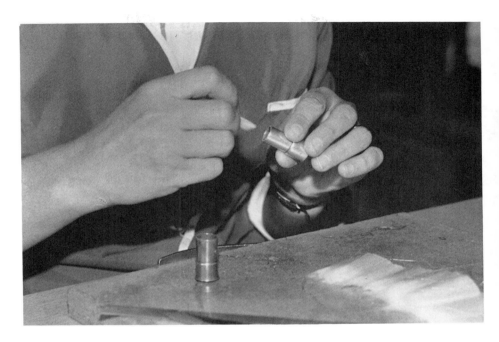

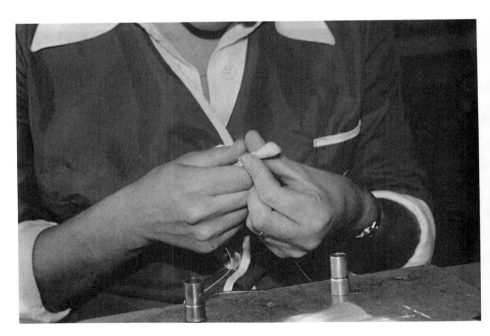

Top: The tied tuft is removed from the mold. *Bottom:* The brushmaker manipulates the hairs to improve the point and shape of the tuft.

Handles

Artists' brush handles are usually made of beech or other hardwoods. Most manufacturers have toyed with the idea of plastic handles at one time or another. It has never proven to be economically feasible because of the large number of sizes required and the high cost of making molds for plastic. In addition, plastic handles have never seemed to please the consumer.

Artists' brush handles vary in diameter, depending on the size of the opening at the base of the ferrule. They are slightly conic, to ensure a better fit. The length of the handles normally remains constant within a given series, even though diameter varies from size to size. A size 2 brush has the same length handle as a size 12. (An exception to this rule, certain watercolor brushes have *albata* handles, which are made in graduated sizes that increase in length as the numerical size of the brush increases. They are, obviously, more difficult and more expensive to manufacture).

Oil and acrylic brushes have long handles, because they are used by a painter standing at an easel. The longer handle permits the artist to stand back from the canvas while working and have a better view of what is being painted. During periods in history when large paintings were popular, oil-painting brushes had longer handles.

Although handle lengths are not precisely standard among different manufacturers, most manufacturers use handles of similar lengths for similar brushes.

Whether long or short, there are several different types of handles available: raw wood, varnished, tumbled, and dipped. Unfinished, or raw, wood handles are the least expensive, but they are very absorbent and quickly soil. Varnished handles are raw wood handles that are sometimes stained before being varnished. They are relatively inexpensive and present no major disadvantages. Tumbled handles are produced by placing many raw wood handles in a revolving drum containing precise amounts of paint or lacquer. As the drum turns, the handles receive a coat of color. Tumbled handles are not very attractive and are used mainly for scholastic-grade brushes.

Most high-quality brushes have dipped handles, which are the most attractive and expensive. They are made by fastening raw wood handles, properly spaced, on rectangular slabs (fig. 2-15). The handles are then lowered into tubs containing primer, lacquer, or varnish. The slabs are raised and allowed to dry after each dipping, thus obtaining a perfect finish. The best-quality dipped handles are first dipped

2-15. *Device for dipping brush handles.*

into a primer, then twice into colored lacquer, and finally into clear varnish, for a total of four coats. Decorative tips of another color require an additional dipping. The only disadvantage of dipped handles results from the thickness of the paint film, which can eventually crack and fall away, having been loosened by the liquids used in painting. This usually occurs at the joint with the ferrule and can cause the handles to loosen as well.

Most countries regulate the toxicity of paints and varnishes used on brush handles and similar objects. Therefore, it is relatively safe to assume that the coatings on most artists' brush handles are nontoxic to an acceptable degree. (This does not mean that you should chew on the handles.)

The color of the handle has absolutely nothing to do with the quality of the brush. Colored handles were introduced in the 1950s in an attempt to make brushes more attractive to the consumer; they are strictly marketing gimmicks.

The brush's brand name, size, and country of origin is usually imprinted on its handle. This task traditionally has been done with metal stamping dies, which etch the characters into the handle finish. Stamping is the best and most permanent way of marking, but it is also the most expensive. In addition, if the copy is very long, a double stamping may be required. Many manufacturers have switched to less expensive methods of marking the handles, such as printing with ink. The ink quickly wears away after the brush is used, leaving an unidentifiable brush. Such marking is suitable only for low-grade inexpensive brushes.

When selecting brushes, one should bear in mind that the fancier the handles are, the more expensive the brush will be.

Constructing a Brush

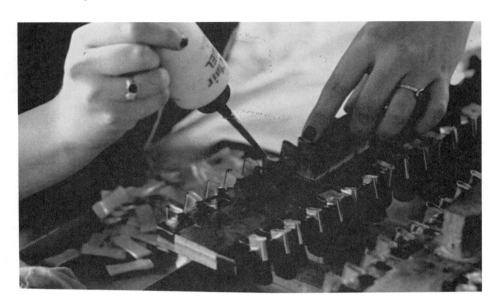

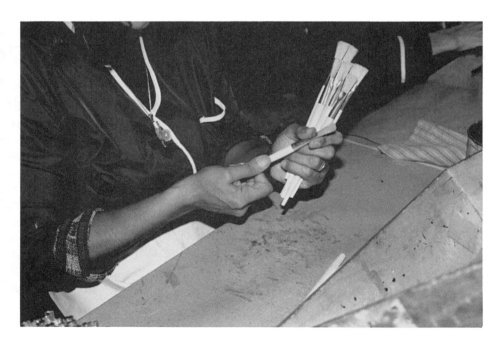

Top: Liquid glue is inserted into the ferrule to secure the tuft.
Bottom: The handle is then inserted into the ferrule.

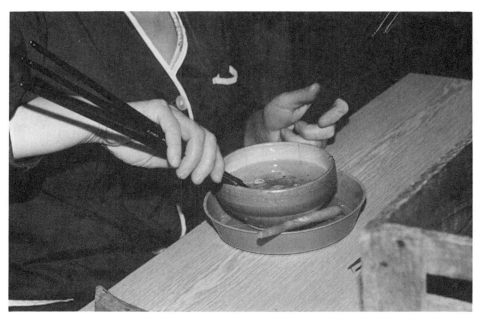

Top: The ferrule is crimped to lock the handle in place. *Bottom:* The tuft is then sized with a solution of gum arabic to protect it.

Quill Brushes

Quills are made in much the same way as other artists' brushes are, except that hollow tubes cut from the base of bird feathers are used instead of metal ferrules.

Duck, goose, and turkey feathers are currently used. When they were available, swan and condor feathers were once used to manufacture large brushes. Quill ferrules, which are softer than metal ones, were once preferred by many brush manufacturers, as well as by artists and craftspeople. They are still very popular for sign painting, fabric painting, and porcelain painting.

To make quill ferrules, the feathers are sorted into batches based on the diameter of the base. Tubes of specific length are cut from the base and are once again sorted into groups, each having the precise diameter required to manufacture the different brush sizes. The tubes are then reamed out to clear the hollow interiors completely, enabling the tufts and the handles to be inserted without difficulty. The tubes are then left to soak in a pot of hot water to soften them. Meanwhile, the tufts are formed in brushmakers' molds and are tied in two different places near the base. They are then cut evenly at the heel (fig. 2-16). The quill ferrules are removed one at a time from the hot water. The finished tuft is immediately inserted, base first, into one end of the still soft quill. Thin brass wire is then wrapped around the quill and twisted very tightly, compressing the quill into the base of the tuft (fig. 2-17). No glue is needed because the tuft will be mechanically locked into the quill once it has cooled and hardened (fig. 2-18). The brass wires can then be removed.

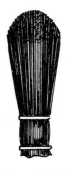

2-16. Tufts for quill brushes are tied twice to secure them.

Quill brushes were once sold without handles, which were available separately and were inserted by the consumer. This practice is no longer common, because the brittle quill was easily split when the handle was inserted. Instead, the handle is inserted at the factory, while the quill is still soft. The quill then shrinks onto the handle as it hardens. Neither wiring nor glue is needed. Cylindrical fitted quill handles are preferable to conic handles because they fit the shape of the quills better and are less likely to cause the quill to split, but they are more expensive and harder to find (fig. 2-19).

Extra-large quill brushes require a slightly modified procedure, because feathers with diameters to accommodate the large tufts are not often available. After the quill tubes are softened in hot water, they are cut lengthwise, opened, and flattened (fig. 2-20). Several pieces of quill are then wrapped around large tufts and are wired tightly at two separate intervals while the quills are still soft. Specially de-

2-17. *A wire is used to compress the quill around the tuft.*

2-18. *The wire can be removed after the quill is hardened.*

fitted

conic

2-19. *Handles for quill brushes.*

2-20. *A large quill brush is made from several pieces of quill.*

2-21. *Handle for a large quill brush.*

2-22. *Large quill brush with the quill and handle secured by wires.*

signed handles (fig. 2-21) are inserted at the base and are also secured with wire (fig. 2-22). No glue is used; if the brass wire is removed, the entire brush will fall apart. (Unfortunately, some manufacturers have begun using steel wires, which rust, instead of brass. The reason given is that certain fabric-painting dyes have been known to dissolve brass wiring.)

Natural bird quill is an excellent material that is impervious to most solvents; however, it is difficult and expensive to prepare. To lower costs, some factories are now using plastic tubing instead of natural quills. The resulting brushes are of inferior quality, because plastic tubing does not shrink around the tuft, locking it in place. Moreover, plastic is less attractive. It should cost less, but the consumer may be encouraged to believe that genuine quill, rather than plastic, was used.

Before the turn of the century, it was customary, for decorative purposes, to dress the tufts of quill brushes by wrapping them with colored silk thread, which completely covered the brushmaker's string. Each individual series was dressed with a different color of thread, which could be clearly seen through the semitransparent quills. Some quills that are dressed with silk thread are still manufactured.

Making a Quill Brush

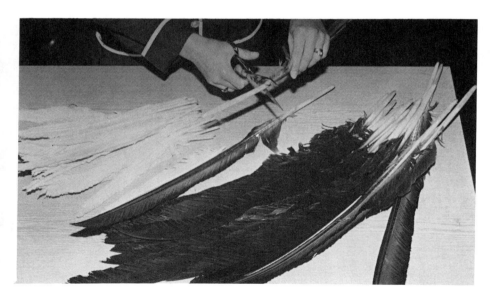

Tubes are cut to specific lengths from feathers.

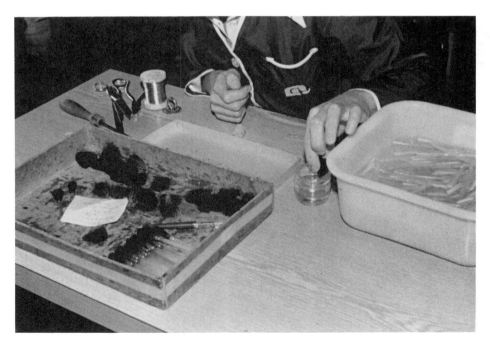

Top: The tubes are sorted by diameter and reamed. *Bottom*: They
are then soaked in boiling water and removed one at a time.

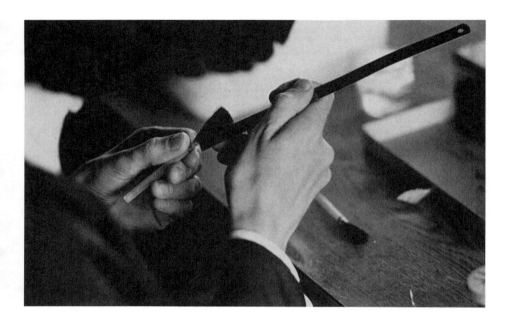

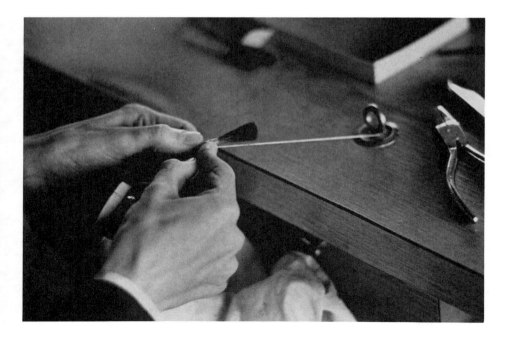

Top: A finished tuft is immediately inserted, base first, into the softened quill tube. *Bottom*: Thin brass wire is tightly wrapped around the soft quill tube, compressing it into the tuft.

Machine-made Brushes

A number of different systems are used to produce tufts and finished brush heads mechanically. The best of these, a system for the production of tufts, consists of round stainless-steel disks containing many circular cavities of equal size that correspond to the diameter of the tufts to be made (fig. 2-23). Bundles of cylindrical or inexpensive conic-shaped hairs of equal length are placed on the disk, points up, and forced down into the cavities by beating the tops of the bundles with a wooden paddle. (The hairs used are not of top quality, since no one would dream of beating the tops of a bundle of kolinsky sable!) A second disk with protrusions that are round for making round or pointed brushes or flat for making square brushes is then forced into the base of the disk containing the hair. The stacked disks are then set on a small machine equipped with a vibrating platform. They are left to vibrate until all of the hairs have descended, roots first, to the bottom of the cavities, giving the tufts their shape. The bottom disks are then removed, and glue is injected into the cavities near the base. When dry, the tufts are forced out. The machine-made tufts are then inserted into ferrules and glued exactly as if they were handmade.

The quality of brushes with machine-made tufts is often quite satisfactory but is never as good as that of brushes with top-grade handmade tufts. When compared with middle-priced scholastic-grade brushes containing tufts that

2-23. *Molds for automatic tuft production.*

2-24. *Machine-made tuft, showing heel of glue at base.*

have been simply hand-cupped in ordinary brushmakers' molds, the shapes of machine-made brushes are not as well-defined and regular, and the points are not as fine. Machine-made tufts cost less to manufacture, and the consumer therefore should expect to pay less for brushes made with them.

To determine whether a given series of brushes is handmade or not, take a small- to medium-size brush, and remove the handle. Cut the ferrule lengthwise, from the bottom up, exposing the tuft. Machine-made tufts are easy to identify, because they have a large, even-shaped heel of glue at the base, and they are not tied with string (fig. 2-24). Although some handmade tufts also are not tied, they are very irregular at the base and cannot be confused with machine-made tufts.

Oriental Brushmaking

Factories in the Orient employ traditional methods that are completely different from those used in the West. China is one of the leading manufacturers and exporters of artists' brushes, but brushmakers there do not use brushmakers' molds or cups and appear to have no knowledge of their existence.

They employ remarkable methods to produce Western-style soft-hair brushes. Tails or skins are soaked in a water-base solution until the hide begins to rot. The brushmaker then grasps the right amount of hair for one brush between the fingers and literally plucks the tuft directly from the skin or tail. The hairs are then rolled until they form a bullet-shaped tuft, which is immediately tied at the base with a string. Dry powdered glue is then deposited on a stone slab, and the tuft is tapped in the glue base. The glue powder is thereby forced upward into the wet tuft, forming a heel of glue at the base. When dry, the tuft is inserted into a metal ferrule, and liquid glue is squeezed into the rear.

Brush heads made in this manner are very irregular: no two have exactly the same shape. Such a brush can come to a point because it contains hairs of many different lengths.

The Chinese also manufacture a very extensive range of Oriental brushes for calligraphy. Inexpensive versions are made of pony or goat hair and have simple bamboo handles. The better grades, made of weasel or kolinsky sable, may have very expensive carved ivory handles.

Such brushes are made in a particularly interesting manner. Wet hair is set out on a stone slab with the points all

facing in the same direction. With a very sharp blade, the hairs are cut at an angle near the base, leaving the points intact (fig. 2-25). The hairs are then rolled into bundles, beginning from the end with the longest hairs, automatically creating tufts that have the longest hairs in the center and the shortest hairs on the outside. As a result, these brushes come to a very fine arrow-shaped point when wet (fig. 2-26). The tufts are tied and glued as Western-made brushes are. Each brush head is then glued, base first, directly into a cavity that has been hollowed out from one end of the handle.

2-25. *Preparation of the hairs for an Oriental pen brush. The wet hairs are aligned with all the points facing the same direction. The hairs are cut at an angle near the base, and rolled into a bundle starting from the longest hairs.*

2-26. *Oriental calligraphy brush.*

Hairs and Bristles

Although hairs and bristles are the most important components of brushes, very little precise information about them has been available to the general public, giving rise to a number of misconceptions. For example, although camel-hair brushes are sold everywhere, real camel hair has never been used for brushes. The originator of the term was supposedly a certain nineteenth-century brushmaker named Camel, who, rather than reveal the types of hair contained in his mixtures, called them camel hair. The better grades today are usually mixtures of squirrel and pony hair, but so-called camel hair could be just about anything.

The term *sable* is also a misnomer: the hairs from the animal called a sable (*Martes zibellina*) are not used for brushes. Rather, sable brushes are made with hair from various animals in the weasel family. Indeed, brushmakers never refer to "sable" when ordering hair. The best grades are kolinsky tail hair, and the less expensive varieties are weasel tail hair (called red sable).

The various types of hair and bristles and their characteristics will be discussed individually in order of their relative merit, beginning with the best and most expensive. Many of the different types of hair can be seen most clearly in the color photos in this book.

Kolinsky

The kolinsky (*Mustela siberica*) is a species of mink and a member of the weasel family, native to Siberia and northeastern China. Without doubt, kolinskies supply the best conic-shaped hair available for the manufacture of artists'

brushes. The high cost of the hair is its only major drawback.

Only hair from the animals' tails is used to manufacture artists' brushes; the pelts are used in the fur industry. The fur has a golden brown color.

Kolinsky tail hair is characterized by very fine long points and thick bellies. Despite their fine softness, the hairs are highly resilient and can pick up and spread the thickest paints.

European-dressed kolinsky hair is superior in quality to and more expensive than hair prepared in Asia.

Hair from male animals is better than that from females. Male hair is longer, stronger, and has more snap. Female hair is lifeless by comparison. Male kolinsky hair is available in lengths of from 28 to 75 millimeters (1 1/8 to 3 inches). Male tails are about 12 inches long; female tails are only about 6 inches long. Most kolinsky brushes contain a mixture of 60 percent female tail hair and 40 percent male tail hair.

Once kolinsky hair has been cut from the tails and packed in bundles, it is very difficult to identify its source as male or female. The only way a brushmaker can be sure he is using male hair is to buy raw kolinsky tails and dress the hair in-house. Raw kolinsky tails can be purchased in assortments containing three female tails for every two male tails. The brushmaker can then separate the large male tails from the smaller female tails before dressing the hair. One can also buy all-male first-grade kolinsky tails, thereby ensuring the quality without having to sort through the tails.

Some of the very best professional-grade watercolor brushes are made completely from male kolinsky tail hair. They are more expensive than those containing both male and female hairs. The difference in quality, however, is well worth the difference in price.

Most people who buy, sell, or use brushes cannot even distinguish between kolinsky and weasel hair, let alone all-male kolinsky hair from male and female hair. Brushes containing all-male tail hair are much more resilient. When they are wet and points of the tufts are bent, they snap back to their original position. Select several different new "sable" watercolor brushes of medium size (number 5 or 6), and carefully comb out the gumming before wetting the brushes. Then soak them in water for five to ten minutes. Break them in by working them on a piece of watercolor paper until they point up properly. Take each brush and hold it perpendicular to the surface. Lightly compress the tip until the point bends over sideways, then lift the brush and examine the point. Those made of all-male kolinsky tail hair will snap right back to a straight position, whereas those made

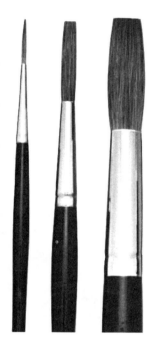

3-1. Red sable showcard lettering brushes. (Courtesy Grumbacher)

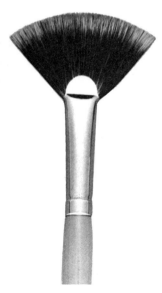

3-2. Black fitch fan blender. (Courtesy Grumbacher)

with male and female hair or with red sable (weasel) will remain slightly bent. It is extremely important that there be strength in the point, because it is the point that spreads the paint.

Weasel

Weasel tail hair is commonly used to manufacture most medium- and low-priced red sable brushes (fig. 3-1). The weasel is a small member of the family Mustelidae, the weasel family, and is native to North America, Europe, and Asia, but only weasel tail hair from Asia is long and fine enough to be suitable for brushmaking. At present, the Chinese are the main suppliers of this type of hair. Weasel tails are about half the size of kolinsky tails. They can be distinguished by their reddish brown color; kolinsky is golden brown. Weasel hair is also shorter than kolinsky hair.

Like kolinsky, weasel hairs are conic and have points and bellies similar to kolinsky hairs. Good-quality red sable brushes normally retail for about 40 percent less than kolinsky brushes of the same diameter. They are a good alternative for those who cannot afford kolinsky.

It is important to be able to distinguish weasel from kolinsky, because red sable brushes containing weasel hair are often passed off as being top-quality and sold at prices that approach kolinsky sable brushes.

Almost all sable brushes sold for oil and acrylic painting contain weasel hair. The solvents and the rough painting surfaces used with these media quickly wear out even the most expensive hairs, and using the most expensive kolinsky hair would be impractical.

Fitch

Closely related to the ferret, the fitch (*Mustela putorius*), also known as polecat, is a member of the weasel family found throughout Europe and Asia. The best varieties come from Siberia and northeastern China. The color of the hair can vary from a light tan to a deep brown-black (fig. 3-2).

Fitch tail hair is a medium-priced, highly resilient conic-shaped hair that has a thick belly. It is equal in quality to weasel (red sable) hair.

This very fine hair, which is often in short supply, makes excellent oil-painting brushes. It is seldom used for watercolor brushes because the assortments made available to

brush manufacturers hardly ever contain sufficient quantities of long hair lengths. Fitch was, and continues to be, highly appreciated for the manufacture of brushes and quills for porcelain painting, particularly in France, where it is known as *putois*.

Squirrel

Two basic types of squirrel tail hair are used for brushmaking: Russian squirrel tail hair and Canadian squirrel tail hair. Russian squirrel is available in lengths of from 40 to 90 millimeters (1²/₃ to 3²/₃ inches) and is superior in quality to Canadian squirrel, which is shorter and used mainly for the production of scholastic-grade watercolor brushes.

Three different varieties of Russian squirrel hair are used for brushmaking: gray, brown, and blue. In the trade, gray Russian squirrel is called Talahoutky, brown is referred to as Kazan, and blue is known as Sacamena squirrel. Talahoutky (gray) squirrel hair is mainly used in the manufacture of sign-painting brushes and quills. It is nearly always in short supply and is considerably more expensive than the other varieties. Kazan squirrel is brown-black and has warm highlights when viewed in natural daylight. It is used mainly for watercolor brushes, wash brushes, and watercolor mops. Sacamena squirrel is blue-black and has cool highlights. The finest and softest of the three varieties, it is considered by many to be the best for manufacturing top-quality artists' watercolor brushes.

Canadian squirrel hair is more intense in color than Russian squirrel hair. It is often yellow-brown with dark brown-black tips.

Squirrel tail hairs are very fine and relatively thin. They are conic shaped and have thick bellies and very fine points.

Squirrel hair brushes point as well as kolinsky and red sable brushes but have very little snap because the hair is not very resilient. Nonetheless, the hair is very absorbent and works very well in medium-priced brushes used for very liquid paints, inks, and dyes. It is totally useless for brushes that are to be used for applying thick paint.

To reduce production costs, manufacturers often mix squirrel hair with less expensive cylindrical hairs, such as pony, and sell these brushes as "camel hair." Brushes made with these kinds of mixtures do not come to a very fine point.

Pure squirrel-hair watercolor brushes are quite popular in certain countries, particularly Britain. In France squirrel hair is called *petit gris*.

Mongoose

The mongoose is native to a number of different countries, but mongoose tail hair from India has proven to be the best quality for manufacturing artists' brushes. It is a very attractive hair that has dark brown tips, a cream-colored center section, and dark roots.

Mongoose hair brushes have been marketed under several different names, including royal sable, crown sable, and royal crown sable. In Spanish-speaking countries it is known as *meloncillo*.

Mongoose is a very good medium-priced hair that is available in assortments containing sufficient long hair lengths. European-dressed mongoose hair is significantly better, and more expensive, than Indian-dressed hair.

Mongoose hair is a very resilient pointed hair and wears very well. It has a great deal of snap, making it ideal for the manufacture of brushes for oil and acrylic painting. Unfortunately, it is not fine enough for good-quality watercolor brushes.

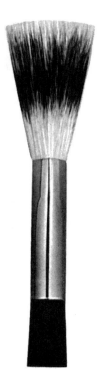

3-3. *Badger blender. (Courtesy Grumbacher)*

Badger

Badgers are native to many parts of the world. China is the main producer of badger hair, the bulk of which is used to manufacture expensive men's shaving brushes.

Badger hair is conic shaped and has a thick belly high up near the point, the root section being relatively thin. This explains the bushy-tipped appearance of genuine badger hair brushes.

The hair, harvested from the tail as well as from all parts of the skin, can vary in color. The most common is light gray with a dark brown-black stripe through the center (fig. 3-3), although dark solid-color hair exists as well.

The best and most expensive varieties are white-tip badger or high-mountain badger, which come from the Pyrenees Mountains along the border between France and Spain.

Badger has traditionally been used for making the blending brushes used in oil painting, and, indeed, the word *badger* has become synonymous with the word *blending*. As a result, many brushes called ''badger blenders'' actually contain no genuine badger hair at all. They are made with imitation badger hair to reduce costs. Imitation badger hair is made by dyeing a dark brown stripe through the center of white goat hair or white hog bristles. Such hairs are easy to

distinguish from genuine badger. If the hair has good points, thick bellies, and thinner root sections, it is badger. If it is cylindrical, curled along the entire length, and has no points, it is probably dyed goat hair. If the hair tips are split in two or more points (see fig. 3-5), it is hog bristle with a stripe dyed through the center.

Sabeline

Sabeline (imitation sable) is ox hair that has been bleached and then dyed to resemble red sable. In France it is called *martrette*.

Most sabeline brushes do not contain any genuine sable hair. They are easy to distinguish from real sable brushes because ox hair does not accept the dye consistently along the entire length of the hairs. Very light colored streaks can be seen along the ferrule line of sabeline brushes (fig. 3-4). Sabeline is sometimes mixed with sable hair to lower the cost of lettering and sign brushes.

Ox

Ox hair is taken from inside the ears of cattle, which are collected from slaughterhouses. There are two basic colors, light tan and dark brown. It is particularly appreciated in Italy and in Germany, which is the major producer of ox hair for brushmaking.

Because it is cylindrical, ox hair does not come to a point or fine edge. The hair is, however, very resilient, and ox hair brushes have a good deal of snap.

Ox hair is used mainly to make flat brushes. It is often mixed with squirrel hair to improve the resiliency of certain types of sign-painting brushes

Pony

Pony is a cylindrical hair that is less expensive than squirrel and more expensive than goat hair. It is found in different colors, but only dark brown hair is used for artists' brushes. It has a dull, matte appearance.

Most pony hair is dressed in Japan or Europe, but the bulk of raw material comes from China, where it is known as horse-body hair.

3-4. *Sabeline flat square wash brush. (Courtesy Grumbacher)*

It is usèd primarily for making school-grade watercolor brushes and lacquer touch-up brushes. Most small cosmetic brushes are made of pony hair. Although it does not point well, it is often mixed with squirrel to reduce cost, and is used in camel hair brushes.

Goat

Goat hair is cylindrical and wavy along its entire length, making it quite easy to identify. It is used mainly for making cosmetics brushes and is not a very good hair for brushes that are to be used wet.

Most goat hair is prepared and dressed in China, the major supplier of goat hair. It is cut from all parts of the animal and is available in three colors: black, white, and gray.

There are two basic grades, single drawn and double drawn. Double drawn is twice-cut hair taken from the root section of longer lengths; it has no natural hair tips. It is less expensive than single-drawn hair, which retains the natural tips.

Some very special types of single-drawn goat hair, taken from selected parts of the animal, are carefully dressed by the Chinese for the manufacture of Oriental calligraphy brushes. These extra-select grades are not very well known to Western brush manufacturers, and the hair is hardly ever exported from China.

In the West, black goat hair is used to manufacture watercolor mops, and it is often mixed with pony hair to make school-grade camel hair watercolor brushes. White and gray goat hairs are also mixed with other hairs to make imitation badger hair.

Synthetic Fibers

During the 1950s cylindrical nylon filaments were introduced for the manufacture of house-painting brushes. These fibers were similar in diameter to hog bristles but lacked the flag, or natural tip. To improve their performance, the ends of the fibers were crushed to split the tips, which could then be sanded to reduce their diameter. These nylon fibers were also used to manufacture easel brushes for acrylic painting.

Early in the 1970s a Japanese producer of nylon fibers, the Toray Rayon Company, discovered a technique for creat-

ing points similar to those of natural hair at the tips of these cylindrical filaments. The process was originally intended to be used to produce pointed synthetic hairs for wigs. The fibers were white but could be dyed to resemble natural hair.

These fibers immediately interested several manufacturers of artists' brushes. They were made available to the trade in 2-inch-long bundles, in three different diameters: very thin, like squirrel; of medium diameter, like sable hair; and relatively thick, like hog bristles. The best results were obtained by mixing the thin and the medium diameters.

Synthetic hair is considerably less expensive than good natural hair. Nonetheless, small synthetic hair brushes cost as much to make as small sable brushes, because synthetic hair is always produced 2 inches long and has to be cut at the base to make the short hairs needed for small brushes. The remnants are discarded at a loss. Small sable hair brushes are therefore usually no more expensive than small synthetic hair brushes. Synthetic hair brushes do become increasingly less expensive in comparison to sable brushes as the size of the brush increases.

Toray synthetic hair is currently available in white, sable brown, orange-brown, and black. Unfortunately, every brush manufacturer has given the hair a different name, and most consumers are unaware that the brushes all contain hairs of the same origin.

Synthetic hair is often mixed with various types of natural hair. Brushes containing synthetic hair are easy to recognize, despite the different colors and the various brand names, because each hair is pointed only at the tip; the rest of the hair shaft is cylindrical. Such brushes thus have points but no bellies. Moreover, synthetic hair reflects light differently than natural hair does.

Synthetic hair is used primarily to manufacture medium-priced artists' brushes for watercolor and acrylic painting. Although not a perfect substitute for top-quality natural hair, the development of pointed synthetic hair represents the most significant innovation in the manufacturing of brushes in the twentieth century. Its success has done much to help control and stabilize the price of natural hair. Nonetheless, the product is not without its disadvantages:

- Synthetic hair brushes point well, but the points are not as fine as those of high-quality squirrel or sable hair brushes.
- The fibers are absorbent but feed liquid paints and inks onto the painting surface too rapidly.
- The hairs are too resilient, so that the brushes often have too much snap, resulting in less control of the brush-stroke.

- The surface of the hair is very smooth, so that picking up and spreading thick paints is more difficult.
- Synthetic hairs do not wear in the same way that natural hairs do. Instead of wearing away, the points of the hairs appear to curl up. When this very annoying problem occurs, all you can do is discard the brush.

The characteristics of synthetic hair are considerably improved when it is mixed with natural hairs. The percentage of natural hair contained in these mixtures must be relatively high to have a significant effect—at least 40 to 50 percent. By the same token, the qualities of many inexpensive natural hairs are improved when they are mixed with synthetic hair. Mixing synthetic hair with certain very fine natural hairs, such as squirrel and sable, however, does nothing to improve their characteristics.

Unfortunately, a number of manufacturers currently produce artists' brushes marketed as a blend of synthetic and natural sable hair that actually contain as little as 10 to 15 percent kolinsky or red sable hair. Theoretically, it is entirely possible that some so-called pure sable brushes could contain as much as 20 to 30 percent synthetic hair, without the deception being noticeable.

Other Hairs

Many other types of natural hair have been used for manufacturing artists' brushes, including civet cat, bear, wolf, dog tail, cat tail, and even rabbit hair. They are not of sufficient interest to merit discussion in detail.

Hog Bristles

The collection and preparation of hog bristles for brushmaking is a relatively important industry when compared to the significance of other hair. Hog bristles are used to manufacture many different types of brushes and brooms for household and industrial use, including housepainting brushes, clothes and shoe brushes, toothbrushes, and push brooms.

At one time, very good bristles were produced and dressed in Europe. In recent years, however, China has become the world's major supplier. The various types of bristles are marketed under the names of the regions where

they are collected, dressed, and sold. The most famous are Chungking, Shanghai, and Hankow bristles.

Hog bristles can be white, brown, black, gray, and spotted. They are supplied in bundles and are delivered in heavy wooden cases. Sold by the kilogram, they are less expensive than the hairs that have been discussed heretofore. A wide selection of different lengths is available, up to 8 inches long. The longer lengths are from mature animals. It has become a common practice to slaughter hogs at a younger age, making very long lengths increasingly difficult to find, and thus more expensive.

Only bristles that have been boiled are suitable for making artists' and house-painting brushes. Unboiled bristles bend over sideways when wet.

For professional brushes, only white bristles are used. (Black bristles are used for making school-grade easel brushes.) There are two types of white bristles: natural, which have a color similar to straw, and bleached white, which are almost white. The bleaching is done both for aesthetic reasons and to render the bristles slightly softer. Natural hog bristles are not pointed at the tips. Instead, they are flagged; that is, the ends are split into two or more parts (fig. 3-5). The flags enable the paint to be evenly spread onto a surface. If they are cut, the brush will leave streaks. During the preparation of the bristles, care must be therefore be taken to ensure that the flags remain intact. Brushmakers must exercise the same care and avoid cutting the tips of the brushes.

3-5. *The split, or flagged, tips of natural hog bristles.*

Chungking bristles are considered to be the best for oil-painting brushes because they are very resilient and have very long, deep flags. Theoretically, the longer the flags, the better the bristles.

The flags of bristle brushes can be seen with the naked eye. Brushes with 80 to 90 percent flagged bristles are best. They have an awkward, bushy appearance because all those tiny flags protrude in all directions. Most artists, however, prefer the neat appearance of brushes that have been cut, with only 10 or 15 percent of the flags remaining.

If a good bristle brush is soaked in water, the flags absorb the liquid. The tips of the bristles become darker, changing color. They absorb paint in the same manner.

To obtain smooth, flawless paint application, a selection of very good white bristle brushes is indispensable, a far less expensive alternative to buying professional-quality soft-hair brushes.

Styles, Shapes, and Qualities

Historians and art experts frequently discuss the nature of brushstrokes visible in the paintings of important artists, but they often neglect to mention the types of brushes used. But brushstrokes cannot be analyzed without knowledge of the brushes that made them, because the characteristics of brushstrokes are largely determined by the brushes employed.

When brushes are used in a traditional manner, the shapes of the brushstrokes are determined by the shape, width, and length of the brush tuft, the movement of the artist's hand, and the degree of pressure applied. The type and thickness of the paint and the characteristics of the support or ground also play important roles.

During certain periods in history, it was considered unfashionable to allow brushstrokes to remain visible, although they can usually be seen somewhere in the painting if you look carefully. The opposite has also been the case; indeed, some schools of painting have encouraged the incorporation of bold, visible brushstrokes as an indispensable part of their technique. In addition, a number of different schools of tole and decorative painting employ methods based on a predetermined range of specific brushstrokes, which require the use of a fairly extensive assortment of brushes of different shapes and sizes.

It is not at all the intention here to encourage the purchase of a large selection of brushes. However, it would be unrealistic to become a one-brush painter without ever having tried a fairly extensive variety of styles, shapes, and sizes.

The illustrations in this chapter serve as the basis for the discussion of brush types. (To facilitate recognition and comparison, the forms of the tufts are slightly exaggerated in the drawings.) The illustrations represent the most commonly used brush styles. Although individual brushes will

vary in diameter, length out, and thickness, depending upon manufacturer, basic shapes within types are very similar. Bear in mind that no two handmade brushes have exactly the same shape. They will vary even when made by the same brushmaker. Moreover, in most factories several people are usually assigned to make the same series, so variations in shape are very likely to occur.

All of the brushes are shown with metal ferrules (with the exception of figure 4-4*b*); however, all round brushes can also be made with natural quill ferrules.

During manufacturing, all flat brushes start out in round ferrules. The tufts are finished, inserted in the ferrules, and adjusted to the right length. The tufts and the ends of the ferrules are then flattened with brushmaker's pliers, which have no teeth, to prevent scratching the ferrules (fig. 4-1). The tufts are then glued into the ferrules. In other words, filberts (figs. 4-2*c*, 4-2*f*, 4-2*i*, 4-3*f*, and 4-3*i*) and flat oval brushes (fig. 4-5*c*) are actually dome-shaped rounds that have been flattened. And cat's tongues (figs. 4-2*a* and 4-3*b*) and flat pointed oval rounds (fig. 4-5*d*) are simply pointed rounds that have been flattened.

The more a brush head is flattened, the thinner and wider it becomes. This important consideration is not apparent in the illustrations but should be kept in mind when selecting brushes.

As a general rule, the thicker the paint, the stiffer the brushes for applying it should be. Long, soft brushes are best suited for the application of very liquid paints and inks.

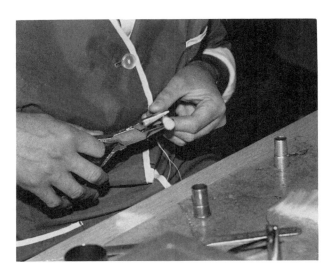

4-1. *A special pair of pliers without teeth is used to flatten the round ferrule of a flat brush.*

Short brushes that are highly resilient are required to apply and spread thick paints.

Watercolor and lettering brushes are usually longer than oil and acrylic brushes. The shorter varieties in each category provide the best control.

Because craft and hobby brushes are simply watercolor or lettering brushes or oil and acrylic brushes fitted with short handles, they will not be discussed separately in this chapter. Also not discussed are Oriental pen brushes for calligraphy; they are made in so many shapes and styles that an entire volume could be devoted to them, and a brief discussion here would be incomplete at best.

White Bristle Oil and Acrylic Brushes

There are two different types of bristle brushes: those with straight bristles and those with curved, or *interlocked*, bristles. Interlocked white bristle brushes (fig. 4-2) contain bristles that curve in toward the center of the tuft. They are considered superior to those made with straight bristles because they retain their shape better. When used to apply paint, they are less likely to spread apart at the tips. They are usually fitted with long handles for easel painting; however, they are also available with short handles for crafts and hobbies.

Interlocked white bristle brushes are usually manufactured in English sizes, numbers 1 through 12. They have very long, seamless, nickel-plated ferrules, known as Hollander ferrules. Inexpensive bristle brushes often have shorter aluminum ferrules and varnished plain-wood handles. They are sometimes marketed in French size, in the even numbers 2 through 24. The actual diameter of French-size bristle brushes is roughly half that of English-size brushes; that is, a French size 2 is equivalent to an English size 1; a French 12, to an English 6; and a French 24, to an English 12.

Cat's Tongue Of the nine shapes shown in figure 4-2, the cat's tongue (fig. 4-2*a*) is the least commonly found in retail shops. Nonetheless, it is very useful for most traditional painting styles, because with it one can paint with the point, with the side edge, or with the flat side of the tuft. The cat's tongue is only manufactured with curved bristles.

Fan Blender White bristle fan blenders (fig. 4-2*b*) are used for a variety of techniques. They were originally designed to blend oil colors that had already been applied to

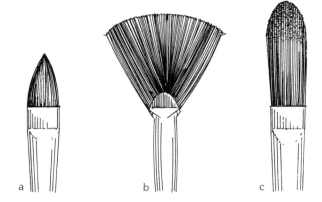

4-2. White bristle oil and acrylic brushes: (a) cat's tongue; (b) fan blender; (c) extra-long filbert (d) round; (e) flat; (f) filbert; (g) short bright; (h) bright; (i) short filbert.

a canvas with other brushes. Today artists often use their fingers for blending, but in the past, this practice was considered unwise because oil paints contained lead and other toxic substances that could enter the body through the skin. Today fan blenders are often used perpendicular to the painting surface, for stippling.

Fan brushes can be made with straight bristles, but the best varieties are made with flagged, curved, bleached white bristles that are set in nickel-plated brass ferrules. They are also made with seamless aluminum ferrules and nickel-plated tin ferrules with folded seams, which are not well suited to these brushes.

Filberts Figures 4-2*c*, 4-2*f*, and 4-2*i* show interlocked white bristle filberts of different lengths. Filberts are flat with oval tips. They are very useful for soft-edge and traditional figurative painting. Filberts can be correctly manufactured from straight bristles as well as from curved bristles.

The extra-long filbert in figure 4-2*c* is particularly well adapted to a very free and bold style of painting. Such a brush can be used to advantage in laying in the initial drawings during underpainting.

Rounds Interlocked pointed white bristle rounds (fig. 4-2*d*) are quite superior to those made with straight bristles, which are usually dome-shaped, not pointed. The small sizes, 1 and 2, are the most popular and are generally used for detail work, in conjunction with larger flat brushes. Many artists, however, paint only with round brushes of all sizes.

Traditionally, round bristle brushes have always had conic-shaped ferrules, so that the tufts could be mechanically wedged and locked into the ferrules. Some inexpensive lines of bristle rounds are now manufactured with cylindrical ferrules; the tufts in these bristles can be pulled right out of the ferrules if they were not properly glued.

Flats and Brights The best-selling white bristle brush styles are flats and brights (figs. 4-2*e*, 4-2*g*, and 4-2*h*). They are manufactured with many different types of bristles, in a variety of ferrules, fitted with handles of assorted lengths. Flats and brights are also the most likely of all the bristle brushes to be cut at the tips, sometimes so badly as to be rendered almost useless.

Flats are traditionally twice the length of brights; however, both styles are commonly available in a variety of thicknesses and lengths.

Flats are best for a free, bold style of execution with paints that are more fluid; brights provide better control of brushstrokes and are best for thick paints.

Fine-Hair Oil and Acrylic Brushes

As a rule, soft-hair easel brushes do not have the same dimensions as white bristle brushes with the same numerical designation. For example, a size 12 bristle brush is much larger than a size 12 sable.

Brushes that contain expensive hairs almost always have seamless nickel-plated brass ferrules. Less expensive soft-hair brushes often have seamless aluminum ferrules or nickel-plated tin ferrules with folded seams. All are usually fitted with long handles except when specifically manufactured for crafts and hobbies.

Soft-hair brushes wear very quickly when used on rough canvases or surfaces coated with an abrasive acrylic ground. In addition, most of the solvents employed to clean brushes used for oil or acrylic paints dry out and damage the hairs. Under these conditions, it is unwise to invest in many very expensive fine soft-hair brushes, although a few small pointed sable rounds and several small fine-hair flat brushes are essential for detail work.

Oil painters who employ traditional techniques and work on smooth oil-primed surfaces often require a wide variety of high-quality fine-hair oil-painting brushes, including some large flat brushes for glazing. Pure kolinsky sable and pure red sable brushes are the best, but they are very expensive and so should be purchased selectively. Brushes with good mixtures of sable and synthetic hairs, of pure mongoose, or of genuine fitch are a good second choice. They are less expensive than pure sable brushes, particularly in the medium and large sizes. Sabeline and ox hair brushes are less well suited for oil painting and should be considered only as a last choice.

For acrylic painting, synthetic hair brushes and brushes with good mixtures of different natural and synthetic hairs are very suitable. Tin ferrules should be avoided because they tend to rust when used in water-base solutions.

Badger Hair Blenders Like the fan blenders, badger hair blenders (fig. 4-3a) traditionally have been used to blend paints after they were applied to the canvas. They were also used in the furniture and frame-making trades to varnish heavily carved objects. Today they are used primarily for stippling They have traditionally been made with pure white-tipped or light gray badger hair set in natural quill ferrules but may also have metal ferrules, which are entirely suitable and less expensive. Because these types of brushes are so large and genuine badger hair is so expensive, badger hair blenders now are often manufactured with imi-

tation badger hair; such brushes are called badger blenders rather than badger hair blenders.

Cat's Tongues The best fine-hair cat's tongues (fig. 4-3*b*) are made with kolinsky sable or red sable hair. Brushes made from fine grades of genuine fitch hair are almost as good. Fine-hair cat's tongues are considered essential by some professionals for very detailed figurative painting.

Fan Blenders Fine-hair fan blenders (fig. 4-3*c*) made of pure kolinsky or pure red sable are on the market, but they are expensive and have no special merit. Pure badger hair or genuine fitch hair fans are the best for oil painting, while good mixtures of synthetic and natural hairs are adequate for acrylic painting. Beware of nickel-plated tin ferrules with folded seams.

Pointed Rounds Pointed rounds with a short length out, such as that in figure 4-3*d*, are best suited for applying modern oil and acrylic paints. They are also slightly less expensive than the longer varieties, such as that in figure 4-3*e*. The small and medium sizes are very useful for painting details with fluid colors. Pure sable oil and acrylic rounds, sizes 2/0 through 4, are preferable and are generally no more expensive than brushes made from other types of hair. Though not as good as pure sable, very good mixtures of synthetic and sable are quite acceptable for the larger pointed rounds. Mongoose hair is not fine enough for the manufacture of good pointed rounds, but some varieties of fine-quality fitch hair are excellent. Sabeline and pure ox hair rounds do not point and so are worthless.

Filberts Fine-hair filberts (figs. 4-3*f* and 4-3*i*) are almost always shorter than white bristle filberts of the same width. They are extremely useful for all types of soft edge and figurative painting. Pure kolinsky or red sable filberts are the best; however, fitch hair or mongoose hair filberts are also very good for both oil and acrylic painting. Sabeline and ox hair filberts are not bad, as long as they have been properly and carefully shaped. Oddly, synthetic hair is totally unsuitable for the manufacture of filberts because it is too resilient. The tufts do not close up when wet; they split. Mixtures of synthetic and natural hairs are only slightly better. The best filberts are relatively thick and shaped with a great deal of care. They cost more to manufacture than brights or other flat brushes of the same dimensions. Beware of filberts that are too thin.

Brights The shorter brights (fig 4-3*g*) are usually the most popular and the most useful. The finest brights are manufactured with kolinsky or red sable hair and cost no

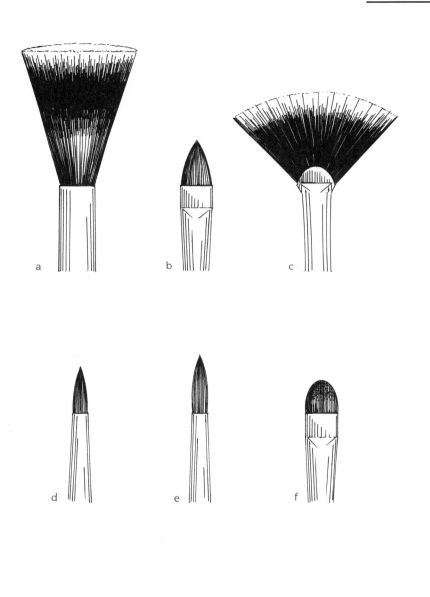

4-3. Fine-hair oil and acrylic brushes: (a) badger hair blender; (b) cat's tongue; (c) fan blender; (d) short pointed round; (e) pointed round; (f) short filbert; (g) short bright; (h) bright; (i) filbert.

more, in the small sizes, than brushes made with other types of hair. In the medium and large sizes (fig 4-3*h*), good mixtures of synthetic and sable, pure mongoose, and genuine pure fitch hair brights are very suitable for acrylics and oils.

Of all the brushes currently on the market, soft-hair brights are the most likely to have manufacturing flaws that are not readily apparent. Brushes sold as pure sometimes contain other types of hair. They are usually too thin, and the tips are often cut, eliminating some, or all, of the points of the hairs.

Lettering and Sign-painting Brushes

At the end of the nineteenth century and during the first half of the twentieth century, the manufacture and sale of brushes for lettering and sign painting represented a major segment of the brushmaking industry. The demand for such brushes has declined over the last forty years with the introduction of markers and various types of transfer lettering. However, the art of lettering is still practiced with traditional methods and materials by some and requires a great deal of knowledge and skill. Indeed, sign painters have always been more concerned about the characteristics and quality of brushes than most fine artists have been.

Outdoor signs are painted with oil enamels and lacquers, which require very long, slightly resilient, fine soft-hair lettering brushes. Gray (Talahoutky) Russian squirrel hair was, and continues to be, the best hair for the manufacture of lettering brushes to be used with these types of paints. When gray squirrel is not available, brown (Kazan) Russian squirrel can be substituted, but it is considerably softer. Both types can be mixed with ox hair to increase resiliency.

Squirrel hair lettering brushes are used in conjunction with large, flat, flagged white bristle brushes. Sign painters create lettering and detail with the fine-hair brushes and use the bristle brushes to fill in large areas and to paint backgrounds.

Various types of water-soluble paints and inks are used for showcard lettering, indoor signs, and calligraphy. Kolinsky or red sable lettering brushes are considered the best; they usually contain varying percentages of sabeline (ox hair), which increases resiliency and reduces cost. Pure sabeline or ox hair lettering brushes are entirely acceptable for students.

Lettering Brushes Figures 4-4*a*, 4-4*d*, and 4-4*g* show long, medium, and short traditional lettering brushes. Extra-long varieties are also available.

Lettering brushes of sable, sabeline, and ox hair are one of the few square brush styles with round, conic metal ferrules. (Most other square brushes have flat ferrules.)

Squirrel hair lettering brushes have tufts of the same shape but are traditionally manufactured with natural quill ferrules. They are sometimes called French quills by sign painters because most are manufactured in France. French quills are available in different lengths and many diameters and are marketed in sizes 1 through 24. Sizes 1 through 10 or 1 through 12 usually have seamless natural quill ferrules. The larger sizes are normally manufactured with pieces of natural bird quill that are wired around the tufts and the handles. Some of the larger brushes may instead have ferrules made from plastic tubing.

Single-stroke Brushes Also called one-stroke brushes, single-stroke brushes (fig. 4-4*b*) are made of sable-ox mixtures or pure light or dark ox hair. They are used to paint large block letters; a single stroke of the brush is required to make a letter, hence the name. They are manufactured in sizes ranging from 1/4 to 2 inches in width, corresponding to the width of the letters that can be painted. They are also used to fill in large areas.

Brushes having a similar shape and called lacquer touch-up brushes are sold as general utility brushes. They are generally less expensive than single-stroke brushes and are popular for craft and hobby painting. They are usually made from pony hair set in aluminum ferrules and are fitted with inexpensive handles.

Truck-lettering Brushes Professional quality truck-lettering brushes (fig. 4-4*c*) are manufactured in the same widths and sizes as single-stroke brushes but are considerably longer. They are used with enamel paints to letter trucks, buses, automobiles, and other objects with smooth metal surfaces. They are usually made from mixtures of Russian squirrel and ox hair.

Script-lettering Brushes Script-lettering brushes (fig. 4-4*e*) can be used as all-purpose liners as well as for traditional cursive lettering. Fine artists, graphic artists, and craftspeople, as well as calligraphers, find them helpful.

When properly constructed, pure kolinsky sable scriptliners are better than those made with red sable hair (weasel). Mixtures of sable and sabeline or synthetic hair are less expensive but not nearly as good.

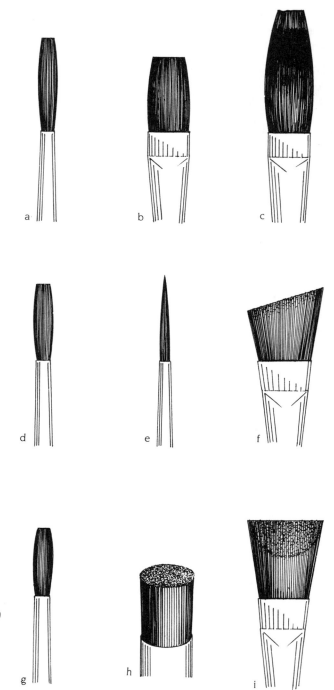

4-4. Lettering and sign-painting brushes: (a) long lettering brush; (b) single-stroke lettering brush; (c) truck-lettering brush; (d) lettering brush; (e) script-lettering brush; (f) angular fitch; (g) short lettering brush; (h) stencil brush; (i) chiseled fitch.

Squirrel hair quill brushes having the same shape, in varying lengths, were traditionally used for painting porcelain.

Fitches White bristle fitches are used with enamels (bulletin colors) to paint outdoor signs and bulletin boards. They are also suitable for many mural-painting techniques. Figure 4-4*f* depicts an angular fitch used for painting, or cutting in, edges. Chiseled fitches, shown in figure 4-4*i*, are hand-cupped to create the special chisel shape, which was designed to allow more of the natural flagged ends to contact the substrate.

Note that, in this context, *fitch* refers not to the type of hair used but to the shape of the brush. Fitches are made with reversed conic ferrules—that is, the tuft protrudes from the large rather than the narrow, end of the ferrule. This accounts for the reversed-arrow look of the brush head and the small, thin appearance of the handle.

Fitches are made almost exclusively with white or black hog bristles; however, different types of fine natual soft hairs can be used.

Stencil Brushes Stencil brushes (fig. 4-4*h*) are made with short, round nickel-plated brass or aluminum seamless ferrules or with nickel-plated tin ferrules with folded seams. They usually have very short wooden handles, designed to fit into and against the palm of the hand. Dome-shaped types made of genuine fitch hair were popular at the turn of the century; however, the model shown is made of white bristle and has a flat top. Stencil brushes are used perpendicular to the painting surface, so the top is what comes into contact with the surface.

Watercolor and Graphic Arts Brushes

Good watercolor brushes will last for several years when used properly with traditional watercolor paints on watercolor paper. The better the hairs, the longer the brushes will last: pure male kolinsky sable watercolor brushes wear considerably better than pure red sable hair brushes and are the best long-term investment. It is better to have three or four sizes of top-quality brushes than a box full of mediocre brushes.

In commercial art, the time spent on a project is calculated into the cost of the finished project. The best and

most expensive brushes are therefore often actually the least costly, because they facilitate the production of the best results in the shortest time.

Manufacturers of artists' brushes are well aware of these considerations, and they know that their entire brush line is often evaluated based on their top-of-the-line watercolor brushes. Many thus make a special effort to improve and maintain the quality of their better grades of watercolor and graphic arts brushes.

The best watercolor brushes are made in England, France, Germany, and the United States. Brushmakers in the Orient have not yet sufficiently mastered the techniques required to make top-quality Western-style watercolor brushes.

Watercolor brushes generally have longer tuft lengths than oil and acrylic brushes and shorter lengths than lettering brushes. The best brushes have seamless, nickel-plated brass or copper ferrules or natural quill ferrules. Aluminum ferrules are acceptable for scholastic-grade brushes. Any type of tin ferrule should be avoided.

Although the best pointed watercolor rounds are made from pure male kolinsky sable hair, it would be prohibitively expensive to manufacture the larger watercolor wash brushes with such costly hair because they are so long and large. The best professional wash brushes thus contain pure Russian squirrel hair. The less expensive versions are mixtures of squirrel and pony hair (these are sometimes mistakenly purchased as pure squirrel hair brushes). Medium- and low-priced wash brushes contain pure pony hair, mixtures of pony and goat hair, or pure goat hair, all of which are often called camel hair.

Mops The wash brush shown in fig. 4-5*a* is called a mop because of its moplike shape, which remains much the same whether wet or dry. Mops are constructed with cylindrical hairs, and the tufts do not close up when wet. They are usually made of pony, ox, or goat hair or mixtures thereof and are considerably less expensive than squirrel hair wash brushes. Mops have large tufts that are composed of a lot of long, soft hairs that soak up fluid watercolor washes over large areas.

Pointed Wash Brushes Round pointed wash brushes (fig. 4-5*b*) usually are made from pure Kazan or Sacamena squirrel hair mounted in natural quill ferrules. When dry, the shape of the tuft is somewhat similar to that of a mop. When wet, the brush comes to a fine point because each hair is pointed and has a large belly. These excellent wash

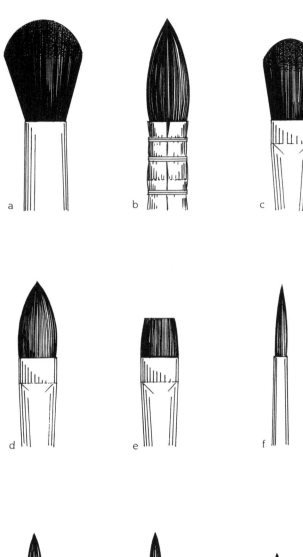

4-5. Watercolor and graphic arts brushes: (a) round oval mop; (b) pointed wash brush; (c) flat oval wash brush; (d) flat pointed oval wash brush; (e) flat square wash brush; (f) fine-pointed liner brush; (g) pointed watercolor brush; (h) fine-pointed graphic art brush; (i) retouching and spotting brush.

brushes are intended for very liquid applications. They are good only when very wet; otherwise, they are lifeless and bend over.

Synthetic hairs are not suitable for the manufacture of these types of large round wash brushes because they do not retain liquid well, and the paint flows down onto the surface too rapidly.

Flat Wash Brushes Flat oval wash brushes (fig. 4-5*c*) are round mops that have been flattened. They contain the same cylindrical hairs and do not point when wet. They are less expensive because they contain much less hair than mops.

Pointed flat oval wash brushes (fig. 4-5*d*) are superior to and more expensive than the nonpointed oval variety. They are generally made from pure Sacamena (blue) squirrel hair, but Kazan (brown) squirrel is also suitable. They come to a fine point when wet and are very useful, in that one can paint with the point, with the side edge, or with the flat side of the brush.

Flat square wash brushes (fig. 4-5*e*) are generally available in sizes ranging from 1/4 to 1 inch. They are similar in shape to soft-hair oil-painting brights. Those made of pure kolinsky or red sable are best if they are not too thin. Mixtures of sable and synthetic hair are acceptable if the sable content is high. Squirrel hair is not often used to manufacture these types of brushes, but it is suitable if the brushes are to be used very wet. Mixtures of sable and sabeline are not bad when the sabeline (ox) hair is shorter than the sable hair and is held back toward the ferrule. Pure sabeline is also acceptable as long as a razor edge at the tip is not needed.

Some watercolorists use only pure sable flat square wash brushes. They do not need pointed rounds for detail work because they use the points formed at the corner tips of the razor edges of these fine brushes. They can produce brushstrokes of different shapes and widths simply by twisting the brushes in different directions.

Flat wash brushes are less expensive than round wash brushes of the same width because they are thinner and contain less hair. They also hold less paint.

Fine-Point Liners Fine-point liners (fig. 4-5*f*) are shorter than script-lettering brushes and are better for all-purpose use because they are easier to control. The best contain kolinsky or red sable hair. Their shape can vary, depending on the method of construction. Some contain hairs of several different lengths and have very thin long points. These often have natural quill ferrules.

Pointed Round Brushes Figures 4-5*g* and 4-5*h* have much in common, but we will deal with the differences first. The brush in figure 4-5*g* has the traditional shape of round pointed watercolor brushes. Such a brush requires the use of a bundle of hairs that are all the same length. The tuft is formed in a brushmaker's mold that has a rounded bottom. The hairs are inserted with the points facing down, resulting in finished tufts that have oval-shaped tips.

Figure 4-5*h* illustrates a round watercolor brush that has a fine point for use in the graphic arts. Such a brush requires the use of a hair bundle containing two and sometimes three different hair lengths. The tuft is formed in a mold with a flat bottom, and the points of the hairs facing up. The finished tuft looks square at the tip. The different hair lengths are often difficult to see with the naked eye because they usually differ by as little as 1 or 2 millimeters. Only kolinsky, weasel, squirrel, and other hairs that have very fine conic-shaped points are suitable for constructing brushes in this manner.

Traditional round pointed brushes have more hair in the points and have slightly thicker bellies than fine-point rounds do. Fine-point brushes are more expensive to manufacture, however, because the different hair lengths must be combined by hand.

Although they are designated as watercolor brushes, both types are commonly used with all types of paints and for a wide variety of purposes, including fine, commercial, technical, and industrial art.

The best pointed rounds have seamless nickel-plated brass or copper conic-shaped ferrules. Aluminum ferrules are acceptable for scholastic grades. Seamed ferrules as well as all types of tin ferrules should be avoided.

Regardless of the shape preferred, a super-fine point should not be the sole criterion of a good pointed watercolor brush. In addition, the bellies of the hairs must be located in the lower half of the tuft, closer to the ferrule than to the point or tip of the brush. This applies to all kolinsky, red sable, or squirrel hair brushes, regardless of the style or shape. (Brushes made from cylindrical hairs lack bellies, of course, and so this criterion does not apply to them.) If the bellies are too high, the brushes will be lifeless and lack resiliency. To place the bellies in the right spot, manufacturers must use longer hairs than would otherwise be required. The finished tufts therefore must often be cut at the base to leave enough room in the ferrules for the handles. Shorter hairs are, of course, less expensive, but if they are used, to lower costs, the bellies of the hairs will be too high. This flaw can be seen with the naked eye when the brushes are wet and assume their shape.

The best hairs for round pointed watercolor brushes are kolinsky sable and red sable (weasel). Squirrel hair is not nearly as good but is still better than other alternatives. Mixtures of these three types of hair with pointed synthetic hair are acceptable if they contain at least 40 to 50 percent natural hair; such mixtures, however, are as expensive as the pure natural hair brushes in the small to medium brush sizes. Brushes containing only pointed synthetic hair are better than those containing only cylindrical hair, such as sabeline, pony, or goat. Relatively inexpensive mixtures of pointed synthetic hair and natural cylindrical hair can be quite good, especially if the natural hairs are held back toward the ferrule, enabling the synthetic hairs to come together at the tips, to form a point.

Beware of very inexpensive sable brushes. Some contain little or no genuine sable hair at all, regardless of what is printed on the package. Others contain sable hair that has not been dressed and sorted by length.

In most countries, good watercolor brushes are marketed in English sizes 3/0 to 14, but this is no guarantee that the diameters and lengths out will be equivalent from series to series, even when made by the same manufacturer. A size 6 watercolor brush that one is considering for purchase may be no larger than the average size 5. This practice is known as downsizing and is used by manufacturers to make certain lines seem less expensive.

Spotting and Retouching Brushes Many brushes used for spotting and retouching are just small watercolor brushes; that shown in figure 4-5*i*, however, has a shape designed particularly for these tasks.

The best varieties are made of pure kolinsky sable, with the bellies of the hairs very low, near the ferrule. This design produces brushes that have very strong, resilient points. Red sable is less suitable for manufacturing brushes of this shape.

The small sizes, 3/0 to 2, are very useful for spotting and retouching. All sizes are very good for use with egg tempera, gouache, and designers' colors.

Brushes with a similar shape, made with Canadian squirrel hair mounted in natural quill ferrules, were once very popular for porcelain painting.

Very small brushes often cost more to manufacture than larger brushes of the same shape. Spotting brushes are a good example. Size 3/0, 2/0, and 0 brushes cost more to manufacture than do size 1 brushes. Very small ferrules are more expensive, and more production time is usually required to make the tiny handmade tufts.

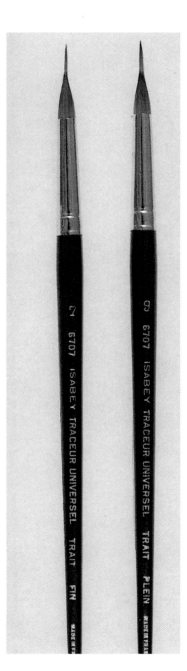

Kolinsky sable universal liners.
(*Courtesy Isabey*)

Synthetic fan brushes.
(*Courtesy Isabey*)

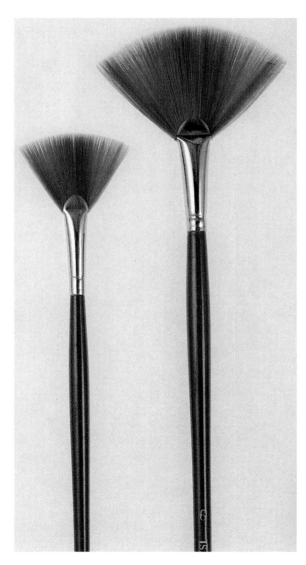

Note: The brushes shown on the following pages are reduced to 75–80 percent of original size.

Pure red sable flat square wash brushes.
(*Courtesy Isabey*)

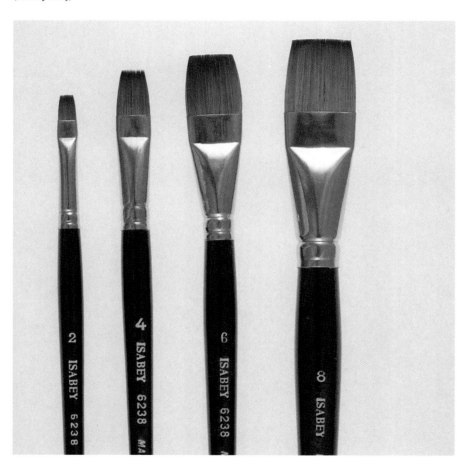

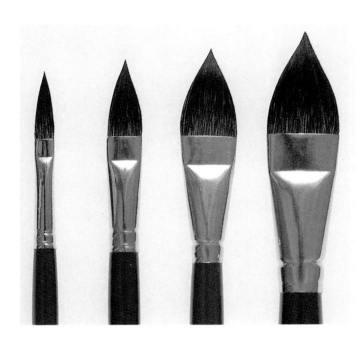

Pure squirrel flat pointed oval
wash brushes.
(Courtesy Isabey)

Pure squirrel watercolor
brushes.
(Courtesy Isabey)

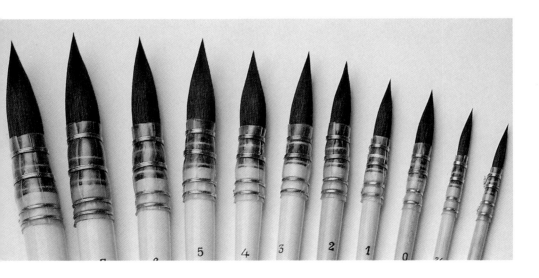

Brushes

White bristle brushes: bright,
flat, and round.
(Courtesy Grumbacher)

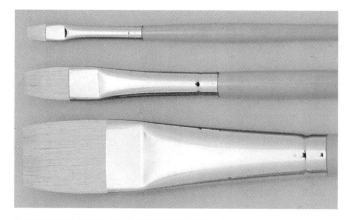

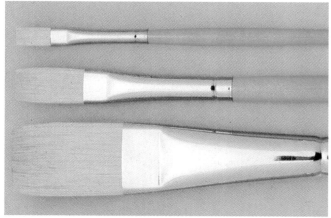

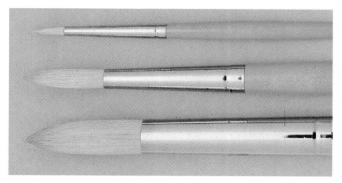

White bristle brush: long
filbert.
(Courtesy Grumbacher)

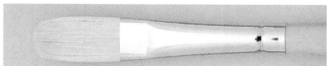

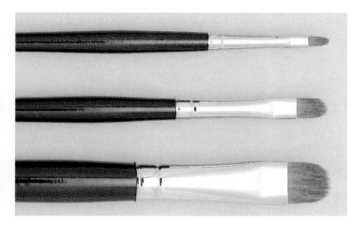

Renoir red sable filbert
oil-painting brushes.
(Courtesy Grumbacher)

Kolinsky sable round
watercolor brushes.
(Courtesy Grumbacher)

Top: Gray squirrel/ox truck
lettering brushes. *Bottom*:
Dagger striper lettering
brushes.
(Courtesy Grumbacher)

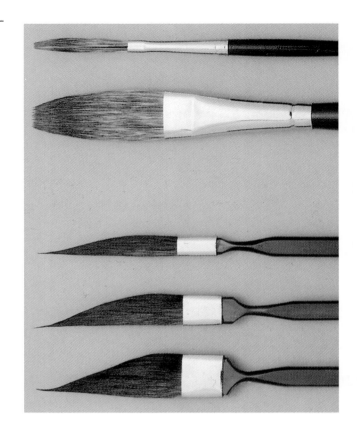

Light ox hair single-stroke
brushes.
(Courtesy Grumbacher)

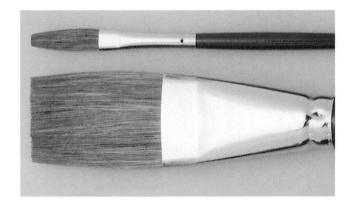

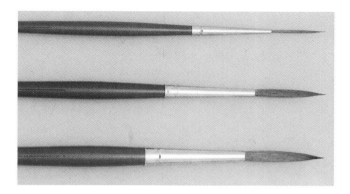

Red sable script lettering brushes.
(Courtesy Grumbacher)

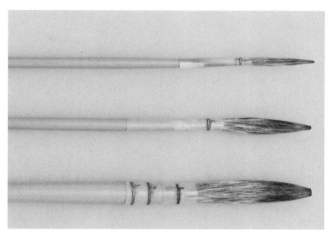

Gray squirrel quill lettering brushes.
(Courtesy Grumbacher)

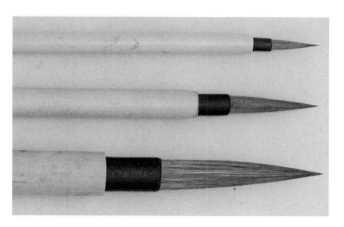

Camel hair bamboo watercolor brushes.
(Courtesy Grumbacher)

White bristle stencil brushes.
(Courtesy Isabey)

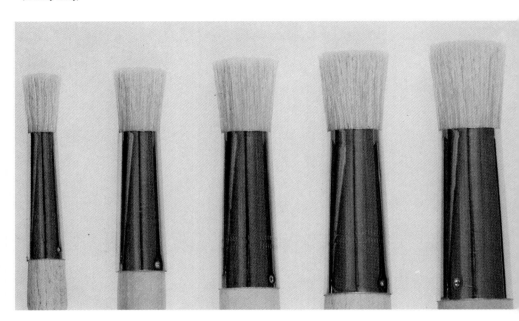

House-paint and Varnish Brushes

Early in the century, house-paint and varnish brushes were manufactured in the same factories as artists' brushes, using the same basic methods and many of the same raw materials. They were very often every bit as good as artists' brushes, the main differences being the sizes and styling of the ferrules and handles. White bristle house-painting brushes were available in the same basic shapes as white bristle artists' brushes; they were just larger. In Europe a few factories still produce high-quality handmade house-painting brushes for professionals. The demand is relatively small, because the general public is not sufficiently well informed to appreciate the real differences between handmade and machine-made brushes.

Most of the house-painting and varnish brushes currently on the market are no longer handmade. The quality of the components and manufacturing methods is completely different. Moreover, many styles and shapes are no longer available. Usually the tuft and sometimes the entire brush head is machine made. The tips of the tufts are cut to give them their final shape. The bristles and hairs are often poorly prepared initially and contain few natural flags or tips.

Worse, most house-painting brushes are fitted with a plug inside the ferrule, at the center of the tuft. The plug is designed to take up space, thereby decreasing the number and cost of the bristles required. The insertion of a plug creates an empty space in the middle of the tuft, just above the ferrule line. Flat brushes are fitted with flat rectangular plugs; round brushes contain round plugs. Plugs can be made of wood, plastic, or cardboard. The tip of the plug can be exposed by sliding a knife blade through the center of the tuft to separate the bristles. One can then look into the end of the ferrule to evaluate the size of the plug used.

Most brushes for painting and varnishing have tin ferrules that are plated with a copper-, brass-, or nickel-colored coating. Many have plastic handles, which is not in itself negative, since there is nothing wrong with plastic handles. The best brushes usually do have wooden handles, however.

These machine-made brushes are suitable for priming painting surfaces with acrylic gesso, but they are not of sufficient quality to be used as artists' brushes.

Before the introduction of spray varnishes, there was a large market for high-quality soft-hair varnish brushes in the furniture, automotive, shipbuilding, and construction indus-

tries. The best were made of pure squirrel hair, fitch, badger, and ox hair. Fine artists had no problem finding good brushes to use for varnishing paintings. Today, good varnish brushes are very expensive and difficult to find. And machine-made varnish brushes can cause real problems. There is nothing more annoying than attempting to varnish a valuable object with a brush that sheds hair all over the surface. It is better to invest in high-quality soft-hair brushes specifically manufactured for flowing on varnish. Large single-stroke lettering brushes and lacquer touch-up brushes can also be used, but they are not as good. Before using a new varnish brush, comb out the tuft to determine if the brush sheds hair. Combing also eliminates any loose hairs, sizing, or dust that the tuft may contain.

Cosmetic Brushes

Traditional cosmetic brushes of high quality have always been similar to good artists' brushes. The only differences were in the length of the handles and sometimes the color of the ferrules.

For the last twenty years, Korea has been the main producer of cosmetic brushes sold in the West by the various manufacturers and distributors of cosmetics. The quality has been significantly diminished. Large powder brushes that were once made of pure squirrel hair are now made of single- or double-drawn goat hair. White goat hair is often dyed in a variety of fashionable colors. Eyeliners and lip brushes that were traditionallly made of pure sable hair now contain brown pony hair or various mixtures. Even human hair is used to manufacture certain types of inexpensive makeup brushes. The type of hair that has been used is never printed on the brush handle, and retail store personnel seldom know what hair has been used.

The retail price of these brushes is very high because so many people are involved in the distribution network. In addition, profit margins in the cosmetics industry are relatively high.

Consumers wishing to purchase high-quality cosmetic brushes at advantageous prices should visit their local art-supply stores. Oval or round watercolor wash brushes make excellent powder brushes. Small sable watercolor brushes are very good eyeliners, and sable filberts make wonderful lipstick and eyeshadow brushes.

All cosmetic brushes should be washed thoroughly with soap and warm water before being used on the skin.

Evaluation and Selection

Evaluating and select-
ing brushes is not as easy as one might think. Many cus-
tomers take a brush directly from the display stand, remove
the protective cap, and plunge the brush into a cup of water
to see if it shapes up properly. This usually results in a sticky
mess, rendering an accurate evaluation impossible.

First the tuft should be examined to see if it has been
damaged previously by other customers. They often re-
move the plastic cap and destroy the tuft when attempting
to replace the cap. It is not unusual to find brushes with sev-
eral hairs bent back, caught between the ferrule and the
cap. These brushes are ruined and represent a total loss for
the retail store operator.

The protective plastic caps serve their purpose well
while the brushes are in shipment from the factory and
when the brushes are in reserve stock. Once removed, the
caps are very difficult to replace without damaging the tufts.
Retail stores would be well advised to remove all caps be-
fore the brushes are put out for sale. This solution seldom
appeals to retail store personnel, but it prevents everyone
from trying to put the caps back on.

Some people dip the brushes in water to shape up the
tufts before attempting to replace the caps. This usually
does not work because the tufts swell when wet. Moreover,
it is not a good idea to put caps on wet brushes: the tufts
will never dry out thoroughly, and the hairs may begin to
rot, particularly possible if they are squirrel, or other very
fine, delicate hairs.

An alternative solution for those who insist on having
caps on brushes is to collect and save all stray caps, and use
those that are slightly larger than the caps originally fitted at
the factory. The larger cap will go over the tuft without dam-
aging it.

The gumming, or protective sizing, of gum arabic solu-
tion applied at the factory can also present numerous diffi-

culties when one is examining a brush. To make a proper evaluation, the gum should be removed before the brush is wet. This can be accomplished by rolling the tuft back and forth between the fingertips while exerting firm pressure. The tuft will break open, and the gumming will begin to powder away. The rest can be removed by inserting the teeth of an ordinary pocket comb into the tuft, down near the ferrule line, and combing out the tuft, working upward from the base to the tips of the hairs.

If the factory applied a gum arabic solution that was too strong, the gumming will be very difficult or impossible to remove entirely. Particles of gum will remain firmly affixed to the very points or tips of the hairs. Avoid purchasing brushes containing very fine soft hairs that have been over-gummed. No gum at all is better than too much.

Once free of gum, and before being wet, the tuft should be carefully examined to evaluate the color, shape, and quality of the hairs. Do not rush through this part of the evaluation, because after the brush has been wet, it is no longer possible to see certain details clearly. The criteria to use in evaluating the different types of hair are discussed later in this chapter.

After dipping the brushes in water, do not be surprised if they do not immediately shape up properly. New brushes that have never been in water must be broken in. Good natural hair that has been properly dressed is slightly water repellent. It must be soaked for several minutes before absorbing enough water to be saturated. Then stroke the brush on a clean, semiabsorbent surface until the tuft assumes its shape. If this does not work, do not be impatient; repeat the whole operation a second time, and the tuft will eventually close up. The points, the shape of the tuft, and the painting edges can then be properly evaluated as described on pages 80-86.

In the studio artists often stick brushes in their mouth to shape up the tufts. They tend to do the same in retail stores when choosing brushes. This practice is definitely not recommended; indeed, it could present serious health hazards. One is never completely sure of the nature and origin of the hairs. Moreover, even if the tuft is clean when it leaves the factory, there is no telling what kind of dirt and germs it picked up in transit. Natural hairs are very absorbent.

Handles and Crimping

One of the easiest things to check is the fastening of the metal ferrule to the wooden handle. If you can hold the ferrule firmly with one hand and spin the handle with the

other, you can expect the handle will continue to loosen and eventually fall out of the ferrule.

There are two basic types of crimping, deep crimping and decorative crimping. Deep crimping compresses the walls of the metal ferrule into the surface of the wooden handle, creating a mechanical lock. The handle is also glued into the ferrule before deep crimping, as an added precaution. Decorative crimping, done for aesthetic reasons, is very superficial; only the glue holds the handle and ferrule together.

Although deep crimping is better, it sometimes causes the ferrule to bend slightly, creating the impression that the handle is not on straight. If one rolls the brush on a flat surface, it will wobble as it rolls. This can often be corrected by exerting a bit of pressure to bend the ferrule back into a straight position, although the handle may be loosened as a result.

Occasionally, brushes have handles that are warped and bent out of shape. The defect should be pointed out to store personnel, who will usually remove the brushes from stock.

Comparing Prices

When comparing the prices of brushes of different brands or series, all having similar styles, shapes, and hair types, do not be too influenced by the size numbers printed on the handles. Measure the inside diameter of the ferrule and the length out of the tufts. All considerations being equal, the best buy is often the brush that contains the most hair for the lowest price.

Manufacturers use different methods to calculate the precise amount of hair used in brushes of a given diameter and length out. The easiest is to weigh one hundred empty ferrules, fill them with hair, and weigh them again. The difference, divided by one hundred, represents the precise weight of the amount of hair needed to make one brush.

Comparisons are not always easy to make. Some factories use a tight ferrule fill; others, a loose fill. Ferrules of exactly the same dimensions can contain different amounts of hair, thereby changing the manufacturer's cost. The difference in thickness can often be felt by compressing the tuft with the fingertips. Sometimes there is so little hair that, if you push the tuft off to one side, you can actually see down into the ferrule.

Some large soft-hair brushes may appear thick and hard near the ferrule line but very thin farther up, in the tuft. Suspect that such a brush contains a plug at the center of the

tuft. You can find out for sure by cutting open the ferrule, removing the tuft, and spreading it apart at the base.

Most brush series are manufactured in graduated sizes: as the numerical size and the diameter of the ferrule increases, so does the length out of the tuft. A size 4 brush thus has a longer tuft than a size 3 and a 3 is longer than a 2. Long hair lengths cost much more than short hair lengths, which explains the relatively high prices of certain large brushes.

Sizes and Size Numbers

The problem of brush sizes is directly related to the availability of ferrules and the lack of standardization.

Worldwide, ferrule manufacturers are limited by the diameters and specifications of the different types of metal tubing available locally. Consequently, manufacturers of ferrules in Spain, for example, cannot offer ferrules that have the same dimensions as those made in Germany.

The situation is further complicated by the fact that copper, brass, and aluminum tubing are not always available in identical diameters. As a result, brushes with different types of ferrules usually also have different dimensions. An English number 4 watercolor brush with an aluminum ferrule is not exactly the same size as a number 4 with a nickel-plated brass ferrule.

Even when several different series do have the same type of ferrule and the brushes are made by the same manufacturer, you cannot be sure that all the corresponding size numbers will have the same physical dimensions, since downsizing (putting a large number on a smaller brush) may make a brush appear to be less expensive.

Add the fact that there are no international sizes for brushes, and the problem becomes totally unmanageable. An English number 6 watercolor brush might be equal to a number 12 or 14 in France and to other sizes in Germany, Italy, and Spain. The United States does not have its own brush sizes; however, English sizes are most commonly used. Finally, in all countries and systems of brush, sizes of watercolor brushes, oil-painting brushes, and lettering brushes do not have size numbers and sizes that correspond. A size 12 watercolor brush does not have the same dimensions as a size 12 oil-painting brush, for instance.

All of this is an unavoidably complicated way of saying that the size numbers imprinted on brush handles have little or nothing to do with the actual physical dimensions of the brushes. They are simply a system of order numbers.

Contents and Labeling

Most countries do not regulate the contents and labeling of artists' brushes. The manufacturers, wholesalers, and retailers are fairly free to do as they please.

The names of the actual manufacturers are not always imprinted on the handles. Large distributors and retailers commonly have brushes specially manufactured, bearing the names of their firms or their own private brand names. In the trade, these are known as private-label brushes. Usually the objective is to obtain better prices. There is nothing wrong with this practice, as long as the distributor who orders and receives the merchandise knows enough about brushes to enforce quality control. Unfortunately, this is seldom the case.

Private-label customers (that is, retailers and distributors) often pressure manufacturers to obtain lower prices. Factories often agree to their terms and then produce lower-quality brushes. Some manufacturers do not care how the brushes are made or what they contain, as long as someone else's name is printed on the handles.

While it is not essential that the consumer know the names of a brush's actual manufacturer, such information certainly provides a good measure of extra insurance of the quality, especially if the manufacturer is well known and has a good reputation.

Some countries do not require that the country of origin be printed on the brush handles. Knowing the source of the brush is useful, because manufacturing techniques and materials vary from country to country. Judging a brush is easier when you know where it comes from.

Consumers would be well served if all manufacturers were required to print the exact nature of the hair content right on the brush handles. While some do it well, others do it badly, and some do not do it at all. Pure kolinsky sable brushes should be marked "pure kolinsky," not just "kolinsky." Pure red sable brushes should be imprinted "pure red sable," not just "sable." Pure squirrel hair brushes should be marked "pure squirrel," not just "squirrel." There are brushes that contain as little as 10 percent genuine sable hair, with 90 percent synthetic hair. They are marketed as "a blend of sable and synthetic hair." This misleading description causes consumers to mistakenly assume that the brushes contain more sable than is actually the case. Brushes containing mixtures of several different types of hair are very difficult to evaluate. The truth is that natural hair content of only 10 percent does little, if anything, to improve the characteristics of a synthetic hair brush. This is especially true when the hairs are machine mixed, because

the few natural hairs in the brush often clump together on one side of the tuft.

I have also seen brushes sold as pure sable that, in my opinion, contained at least 20 to 30 percent synthetic hair. Some inexpensive soft-hair brushes, said to be sable, are nothing more than dyed pony hair. They contain no sable at all.

These practices are more flagrant in some countries than in others and will no doubt continue. There is every reason to believe that some manufacturers would resist any attempt to regulate the content and labeling of artists' and craftsmen's brushes. The best advice, therefore, is *caveat emptor*—buyer beware. Learn about traditional brushmaking methods and materials, so that you can make an educated decision. A well-informed buyer can do much to discourage questionable practices.

Evaluating Brush Hair

Artists' brushes are manufactured in small quantities: production runs of five hundred pieces per series and size are not uncommon. Expensive sable brushes are often made in batches of as few as one hundred in a given size. The contents and quality of the brushes sometimes vary from batch to batch. The differences do not necessarily indicate a change in the manufacturing specifications but rather may simply be the result of variations in the availability and quality of the raw materials. Whatever the reason, consumers should be aware that the characteristics and quality of several brushes of the same brand, series, and size can differ significantly. In retail stores, these variations are readily apparent when a new shipment arrives from the factory and the brushes are compared with those already in stock. Slight variations are normal and entirely acceptable; however, any significant downgrading of quality should be brought to the attention of the manufacturer.

In light of current manufacturing and marketing practices, consumers clearly must know how to examine and evaluate the true nature of the hairs contained in the brushes being considered for purchase. Although not difficult to learn, the criteria vary somewhat depending on the styles or shapes of the brushes and the types of hair they supposedly contain. In addition to the information that follows, see chapter 3 for discussions of the different types of hair.

Pure Sable Hair Brushes One of the criteria used in evaluating sable brushes and determining the kind and quality of

sable hair used is the color of the hairs. Kolinsky tail hair is golden brown, whereas weasel tail (red sable) hair is darker and reddish brown. They should be compared in natural daylight, but even then the differences may be difficult to see, especially in small brushes. Examine medium or large sizes. If you still cannot see any difference, take eight or ten large pure kolinsky brushes in one hand and eight or ten large pure red sable brushes in the other. Go to a window, and hold them out at arm's length. The color differences will be more apparent.

Wet or dry, kolinsky sable brushes have more snap. There are also important differences in the handling characteristics, as well as in the strength of the points or tips of the tufts: it is easier to pick up paint and to spread it onto the painting surface with precision.

Kolinsky watercolor and lettering brushes are usually longer than red sable brushes of the same diameter. All other factors being equal, kolinsky brushes are better than red sable brushes. Good red sable brushes, however, are better than badly made kolinsky brushes.

Some sable brushes contain sabeline (dyed ox hair) to reduce their cost. They are easy to spot because the color of the hair is not uniform, and light streaks near the ferrule line are very apparent. In addition, sabeline is a cylindrical hair, and brushes that contain it do not point as well as pure sable brushes.

Other supposedly pure sable brushes may contain synthetic hair that has been dyed a brown sable color. Synthetic hair does not reflect light in the same way as natural sable hair does, but the difference is sometimes difficult to see. Synthetic hair is perfectly smooth along its entire length, whereas natural hair is not. Grasp the tuft of a pure synthetic brush down near the ferrule line. Press down hard with your fingertips while sliding them upward toward the tip. Now do the same thing with a pure sable brush. You will definitely notice the difference. Perform the same test on any brush being evaluated. If it feels smoother than the pure sable brush, it probably contains some synthetic hair. The smoother it feels, the more synthetic hair it is likely to contain.

Synthetic and Natural Sable Hair Blends The evaluation of these mixtures depends on one's ability to determine approximately how much genuine sable hair is contained in a tuft. Such a judgment is very easy to make when the synthetic hair is not the same color as the sable hair. Many blends on the market contain orange-colored synthetic hair. Spotting a few brown sable hairs amid all that orange synthetic hair is easy, even with the naked eye. Moreover, the

sable hairs are often gathered together in one section of the tuft.

Evaluating a mixture is more difficult when the synthetic hairs are the same color as the sable hairs. Then, the smoothness of the tuft must be examined: feel the tuft of a pure sable hair brush, then feel that of a pure synthetic brush, and then compare with the brush in question. The smoother it feels, the less sable hair it contains.

If you are still not sure how much sable is in the mixture, try another test. Genuine sable hairs have thick bellies, whereas synthetic hairs have points but no bellies. Soak the brush in water, shape up the tuft, and examine carefully. If the tuft has no belly, the brush cannot contain very much genuine sable.

Blends that contain very little real sable are not a very good buy. Furthermore, the manufacture and sale of such brushes should be discouraged, since pure synthetic hair brushes are often just as good and less expensive.

If you cannot afford a complete series of pure sable brushes, you are well advised to purchase pure sable brushes in the small sizes and hand-mixed blends containing at least 40 to 50 percent genuine sable in the medium and large sizes. Once you have evaluated the hair blends, make price comparisons.

Finally, good mixtures of kolinsky and synthetic hair are better than blends of red sable (weasel) and synthetic hair.

Pure Squirrel Hair The different types of squirrel hair are easy to identify because they are very different in color. Most people have no trouble distinguishing colorful Canadian squirrel from solid black-brown Kazan or solid blue-black Sacamena Russian squirrel hair. Some manufacturers switch from one type to another depending on the availability of the hair. It is not uncommon to see a brush series that uses Canadian squirrel in the small sizes and Sacamena or Kazan in the other sizes. This practice should be discouraged, particularly for top-of-the-line pure squirrel hair watercolor brushes. Although all are genuine squirrel tail hair, the characteristics of each type are distinctly different.

Gray (Talahoutky) squirrel hair is used primarily for lettering and sign-painting brushes. The color is quite distinct. The hair is expensive and not always readily available. As a substitute, some hair dealers have been know to dress and distribute gray squirrel tail hair from other regions of the world. This hair usually lacks resiliency, and the multitone gray color is often warmer than that of genuine gray Russian squirrel hair.

Beware of squirrel hair brushes that are heavily sized with gum arabic. The gumming may be difficult to remove without damaging the hair.

Examine the texture of the hair closely: it should be glossy and silken. If the tufts have a dull, dry appearance, the hair may be brittle and overdressed. The hair will wear rapidly or break and fall out. Squirrel hair is very thin and delicate.

Squirrel is sometimes mixed with pony hair to reduce the costs. Pony is a rough, dull, cylindrical hair, which is easy to distinguish with your fingertips. In addition, brushes containing pony hair do not point nearly as well as pure squirrel hair brushes do.

Oddly, blends of natural squirrel and synthetic hair are far from as good as one might expect, even when the mixture contains a lot of squirrel hair.

Fitch Tail Hair Fitch hair is generally used to manufacture oil-painting brushes and fan blenders. It can vary significantly in type, quality, and color, as well as origin, from various parts of Europe and Asia. Some fitch hair is solid tan or black, whereas other types are two tones of black or brown, with light cream-color tips. Consequently, many artists find evaluating fitch hair brushes very difficult. Because the color of fitch hair varies so much, it is best to ignore it completely and to base judgment on other characteristics of the tuft. The characteristics of high-quality fitch tail hair closely resemble those of red sable (weasel). The hairs have fine points and thick bellies, and are sometimes more resilient than sable. Evaluate fitch hair brushes exactly as you would evaluate red sable brushes. If the quality is very good, compare the prices. Genuine fitch hair brushes are often a good buy.

There are many imitation fitch hair brushes on the market. They usually contain mixtures of dark cylindrical hair, such as dark ox and pony hair. As a result, the rounds will not come to a fine point when wet and the brights do not close up to form a sharp painting edge.

Ox Ear Hair Light ox hair is finer in quality and only slightly more expensive than dark ox hair. It is well worth the extra cost. Light ox hair is generally less expensive than sabeline (dyed ox) and is every bit as good.

Badger Brushes Four basic types of badger brushes are on the market:
- Genuine badger hair brushes
- Mixtures of genuine badger hair and imitation badger
- Imitation badger hair brushes that contain no real badger hair
- Brushes with genuine badger hair on the outside of the tuft, with other types of hair in the interior

Some are simply called badger brushes or badger blenders. Others are marked "badger hair" but may contain just

about anything. The situation can be quite confusing, particularly when a brush contains several different types of hairs. The only sure way of evaluating the contents is to spread the tuft and examine the shapes of the hairs.

Genuine badger hair is thicker and stronger than sable but, like sable, has points and bellies. The color of the hair can vary. Examine the tips of the hairs. If you see flagged ends instead of points, you are looking at hog bristles, even if you see a dark stripe through the center. If you find hairs with cylindrical tips that are wavy along the entire length, you can safely assume that you are looking at goat hair, regardless of the color.

There is nothing wrong with purchasing imitation badger brushes, so long as you are not fooled into thinking that they are the genuine article. The prices are not the same.

All of the above also applies to badger hair shaving brushes for men. The best varieties are made as carefully and as well as high-quality artists' brushes.

Other Natural Soft-Hair Brushes For obvious reasons, the nature and origins of the hair are of considerable importance when evaluating the merits of expensive brushes. Such factors are of less importance when choosing inexpensive scholastic-grade brushes. While it is certainly interesting to know what type of hair a brush contains, it is more important that the brush picks up and spreads the paint properly. If a brush does not perform well, you should not purchase it, regardless of the price or the nature of the hair. On the other hand, if a brush performs well, though it is inexpensive, you should not be overly concerned about the hair content. It does not really matter if it is made of ox, pony, goat, or rabbit hair.

Inexpensive brushes may even contain a variety of hairs of different colors that have been dyed brown or black for aesthetic reasons. Very inexpensive natural soft-hair watercolor brushes are often dyed. The dyes must be colorfast so as to not bleed into the paint. If you want to be sure, soak the brush in water for a few minutes, then stroke it across the surface of a piece of absorbent white paper. If the dye is water soluble, it will bleed onto the surface of the paper.

Inexpensive Mixtures of Natural and Synthetic Hairs Such blends can be quite good. The characteristics of many otherwise very ordinary natural hairs are often improved when properly mixed with synthetic hair. Compare them to other blends and to kolinsky brushes; if they perform well, these mixtures can be a good buy. Much depends on the knowledge and ability of the manufacturer. Some can make

brushes of acceptable quality with relatively inexpensive raw materials.

Synthetic Hair Brushes The characteristics of synthetic hair brushes have been thoroughly covered in previous chapters. Nonetheless, with so many types, colors, and brand names on the market, the buyer can be easily confused.

It is important not to confuse pointed nylon hairs (imitation sable) with cylindrical nylon fibers (imitation bristle), used to make inexpensive easel brushes for acrylic painting. Synthetic hairs are thinner, have pointed tips, and are more expensive.

Synthetic nylon hairs may be white or one of many different colors intended to resemble the color of natural hair. The color has absolutely nothing to do with the quality of the hair. The chemical composition of the hair is the same regardless of color, and the different diameters produced are standard, despite the many different names given synthetic hair by the various brush manufacturers. But all synthetic hair brushes are not the same. The tufts can be constructed in a variety of different ways. In addition, they can contain hairs of different diameter or mixtures of several diameters. They can be entirely handmade or produced mechanically. The quality and cost of the ferrules and the handles can vary considerably.

All of these considerations being equal, the price of one brand should not be significantly different from another. In general, synthetic hairs are relatively inexpensive, although small brushes are generally not a good buy when compared to small sable brushes, because of the work involved in trimming the synthetic hair.

Pay particular attention to the tips of the hair and to the points of the brushes. They are very easily damaged and bent out of shape and are then almost impossible to straighten. Such brushes are ruined.

White Bristle Artists' Brushes Many oil and acrylic painters pay very little attention to the quality of their bristle brushes, price being the main consideration. This attitude may be well founded when one does a lot of scumbling on rough canvases, because the brushes wear out quickly. Painters employing traditional techniques, however, should attach a certain importance to the quality and form of their brushstrokes. These depend to a large degree on the quality of the bristles and the construction of the tuft. Most painters today do not even know what a good white bristle brush looks like. Many might even hesitate when confronted with the strange appearance of all those fuzzy little flagged

ends protruding in all directions. Those little natural flags are precisely what pick up the paint and spread it evenly on the painting surface.

The quality of white bristle brushes continues to deteriorate because of the miscommunication and lack of understanding on the parts of brush manufacturers, retailers, and consumers.

The Chinese bristle-brush manufacturing industry is a good example. The Chinese are very capable of producing excellent grades of bleached, boiled white bristles of equal lengths, with 80 to 90 percent natural flags. They have several large factories that produce large quantities of white bristle artists' brushes, most of which are exported to the West. These usually have aluminum ferrules and are fitted with long or short wooden handles. Nonetheless, most of the white bristle artists' brushes produced in China are of inferior quality. They contain bristles of different lengths that have very few natural flags.

Worse, to form the tufts, the ferrules are simply filled with bristles, which are just pushed or pulled to the desired length. They are then glued, gummed, and cut to give the tufts a nice finished appearance.

Hog bristles are inexpensive. Even the best-quality bristles do not cost much more than the poorest. But because consumers willingly sacrifice quality to save a bit of money, the industry responds by producing cheap, inferior brushes. The only way to encourage manufacturers to produce high-quality bristle brushes at affordable prices is to refuse to buy poor-quality brushes. Start counting those flags, and buy only brushes with a high percentage of natural flags.

The nature and quality of the ferrules and handles are of secondary importance because the tufts always wear out first. Unfortunately, high-quality tufts, made with the finest bristles, are usually found only in brushes fitted with relatively expensive ferrules and handles.

These considerations also apply to all types of natural hog bristle paint and varnish brushes, regardless of the color of the hair.

Quill Brushes

Choosing among various brands and types of quill brushes can be a problem for those unaccustomed to brushes constructed in this manner. The main objective is to select a brush with a properly made high-quality natural quill ferrule rather than with plastic tubing. The difference is quite easy

to see. Plastic tubing is uniform in color—completely transparent, semiopaque, or opaque white. Natural quills are not. Plastic tubing is soft and perfectly cylindrical, and the ends are completely round. Natural quill is hard and brittle, with an enamellike quality. The shapes and sizes of quills are irregular—no two are exactly alike.

Seamless natural quill brushes can usually be found in diameters of up to 7 millimeters, about the size of a number 12 sign-painting quill. If you can choose between a brush made with two pieces of natural quill and another with a seamless natural quill ferrule, choose the seamless brush. When choosing among several brushes that have seamless natural quills, choose the one with the longest ferrule. Examine both ends carefully to be sure they are not split or damaged.

Select quill brushes that have been mounted on handles at the factory, rather than trying to insert the handles yourself, because the quill ferrules often split during the process.

Troubleshooting and Caring for Brushes

Most reputable manufacturers of artists' brushes guarantee the quality of their products. They will generally accept the return of defective brushes and will replace them. But many of the brushes that are returned to retailers by consumers are not really defective. Instead, they have been ruined by improper use. Often, the same customers who complain again and again about defective brushes are the ones misusing and ruining them. Certain sign painters, for example, habitually return brushes because the hairs are falling out. One only has to smell the odor of strong solvents still present in the tufts to realize that the brushes were used in solvents that dissolved the glue holding the ferrules.

Very annoying disputes and misunderstandings about responsibility for defective brushes consequently often occur among consumers, retailers, and manufacturers. Retailers should learn to recognize brushes that have been misused and should avoid returning boxes full of customer-damaged brushes to the manufacturers. Retail store personnel should be professional enough to be able to deal diplomatically and definitively with customers who return brushes.

It is also imperative that consumers have a sound working knowledge of the proper care of their brushes.

While many brushes that users claim are defective have actually been ruined, just as many brushes that really are defective go completely unnoticed. A good basic knowledge of the most common defects and their causes will go a long way toward rectifying both problems.

Shedding

Brushes that shed hair cause the most customer complaints. Actually, brushes can shed hair for a variety of rea-

sons. Each case should be evaluated separately to determine the cause. There are three major causes of shedding:

1. Despite various quality-control checks undertaken at most factories, it is entirely possible that several brushes in a batch contain little or no glue at all. Depending on the methods employed, it can be relatively easy to skip a few brush heads when gluing several hundred.

2. Many bundles contain a number of hairs that are shorter than the others; these are usually combed out of the tufts during the manufacturing process (fig. 6-1). They are called "shorts," and often a few remain in the tufts of finished brushes. This is the most common cause of shedding.

3. It is not uncommon for some thin delicate hairs, such as squirrel, to break and fall out of the tufts. This problem occurs when the hair has been overdressed, making it dry and brittle.

To determine the exact cause of shedding, comb out the brush over a piece of white paper so that you can see the falling hairs clearly. Then pick up a few and hold them alongside the tuft to check their length.

If loose hairs are long enough to have descended deep into the ferrule, too little glue in the ferrule is likely the problem. If long hairs continue to shed as you comb the brush, it should be considered defective.

Loose hairs that are shorter than the length out of the tuft are broken hairs or are too short to have been glued. If you keep combing and the brush stops shedding, the loose hairs were probably shorts. The brush is not really defective. On the other hand, if the brush keeps losing short hairs

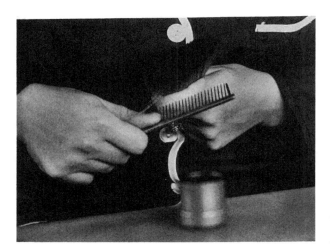

6-1. *Hairs that are shorter than those in the tuft are combed out during manufacturing. Any "shorts" that remain will cause shedding.*

as you comb out the tuft, the hairs are probably breaking, and the brush should be returned to the manufacturer.

Splitting

The tufts of some brushes may split in one or several places when wet. Pointed brushes often split at the tip, creating the impression that the brush has several points. Regardless of whether a brush is round or flat, and no matter where the tuft splits, the cause is always the same. Many bundles of hair contain a few hairs called "butts," which are hairs that have been accidentally reversed during preparation of the hair. They are usually knifed out during production. Any that inadvertently remain in the tufts are glued into the ferrules upside down. One single reversed hair, or butt, will cause the tuft to split open at that particular spot. If the brush splits in two different places, there are two butts in the tuft. Brushes that split are defective and should be returned to the manufacturer.

Cut Tips

Brushes that have been severely cut are not considered defective by most manufacturers. For the end user, it becomes a question of degree. When square brushes are slightly uneven, brushmakers can trim them very carefully at the tips without damaging them, but they often get carried away and cut too deeply into the tufts. More egregious is cutting tips as a standard practice to lower production costs. Some manufacturers actually use machines equipped with large blades to chop off the ends of the tufts.

As a general rule, manufacturers will not accept the return of brushes that have been cut during production, so it is best to avoid buying them in the first place.

Hard Tufts

Hardness at the base of a tuft, near the ferrule line, may signal the inclusion of a plug. Plugs, however, are seldom used in small brushes.

When a tuft is hard in one spot or along its entire width, it is usually because glue has seeped down into the tuft, forming a heel of dried glue in the interior. This flaw occurs

because the glue used to bond the hairs in the ferrule was too liquid.

If you happen upon a brush with a hard tuft, others of the same series and size will probably have the same defect. They should be brought to the attention of retail store personnel, removed from stock, and returned to the factory.

Moth Damage

After fifteen years in the industry, I had never seen brushes that had been eaten by moths. Then, one summer, they ate their way through all of the best kolinsky brushes in my office. Moths can create extensive damage in a brush factory. They can devour several hundred thousand dollars' worth of quality soft hair. Consequently, moth balls are usually placed in cartons where the hair bundles are kept and in the bins containing the finished brush stock. Once the brushes have left the factory, the manufacturers are no longer responsible for moth damage. Wholesalers and retailers thus should adopt similar measures to protect their stock.

Moths usually do not attack brushes after they have been used in paint.

Abnormal Wear

When brushes wear out prematurely, artists sometimes blame the quality of the hairs or fibers. They insist that the quality of the brushes must have changed, because they themselves continue to use the same brands of paint and the same colors. It never occurs to them that the paint manufacturers might have changed something in the colors.

Actually, brushes that wear out faster than normal usually have been used to paint surfaces that are very abrasive or have been used with paints that have a solvent action on the hairs. Consumers often attempt to return worn brushes, claiming that they are defective. Retailers should not accept their return.

Caring for Brushes

The proper use, cleaning, and care of brushes are essential to ensure that they last a long time. The following tips will help you to get the most use out of them:

6-2. A brush washer/holder, used for watercolor brushes. Brushes can be immersed in the liquid without damage to the hairs, or suspended above to dry.

6-3. A brush washer for oil-painting brushes. The cup is filled with solvent above the holder; the brush is stroked across the holes, and the pigment falls to the bottom.

- Artists who intend to use brushes in watercolors, designer's colors, or gouache should avoid using these same brushes in oil or acrylic; otherwise, the brushes will never be as good.
- Expensive brushes should not be used on abrasive surfaces. If they are used to scrub paint onto rough acrylic-primed canvases, they will be ruined in a couple of hours.
- While working with acrylic paints, keep the tips of your brushes in water to keep the colors wet. If acrylic paints dry in the tufts, the brushes will be ruined.
- When brushes are left soaking, they should be placed in a brush holder, such as that shown in figure 6-2, that keeps the brush heads from touching the bottom of the vessel. This will prevent the tufts from being permanently bent out of shape.
- Keep brush handles dry to prevent them from cracking and loosening. Do not overfill the containers that hold your painting media and solvents. When you dip your brushes, the liquid level should be below the crimping, to avoid wetting the handles.
- Clean your brushes immediately after each painting session, using the solvents that you normally use as paint thinner. Avoid using other solvents.
- Periodically, the tufts can be washed with ordinary hand soap in warm water. The tufts then should be reshaped with the fingertips, and the brushes allowed to dry standing in an upright position.
- Do not store brushes in cramped quarters, where they risk being damaged or bent out of shape.

Some Final Thoughts

It would be irresponsible to close any examination of artists' and craftsmen's brushes without discussing the various ecological considerations involved in brushmaking. Most brush manufacturers have very little knowledge about the subject. They deal through intermediaries and have no contact with the suppliers of the hairs in question.

To the best of my knowledge, none of the hairs discussed in this book is from an endangered species of animal. At the present time the supply of natural hair exceeds the demand. Moreover, the total quantity of natural soft hair used in the industry has diminished substantially since the successful introduction of synthetic hair in 1974.

Much of the hair used for brush manufacturing is a by-product of the food industry and thus raises no environmental concerns.

In some cases there may be certain humane factors that should be taken into account.

However, it is no secret that, in some Far Eastern countries, some animals considered as pets in the West are eaten as delicacies. Indeed, dog tail hair and cat tail hair are really quite suitable for manufacturing some types of artists' and cosmetic brushes. Western brush manufacturers generally do not use these types of hair, but large quantities are collected and dressed in China. These relatively inexpensive hairs often find their way into the brushes that are manufactured in certain countries, which are then exported to the West. Regulations requiring the proper labeling of the content of the tufts might serve to discourage these practices but would not be totally effective without some measure of systematic verification of the true nature of the hair actually contained in the brushes.

Other hair used for brushmaking is a by-product of the fur and fashion industries. Some of the animals used are

trapped in the wild. For example, no one has successfully raised and bred the kolinsky or the weasel in captivity. Unfortunately, no other hair is of equal quality for the manufacture of high-quality artists' brushes.

These species, however, are not in any danger of extinction. Moreover, the demand for their pelts and tails has decreased over the last fifteen years, partly because of high prices. When these types of pelts are no longer used in the fur industry, the tail hairs will no longer be available for brushmaking.

The manufacture of artists' brushes by traditional methods remains one of the few surviving industries that is entirely unmechanized: every step is performed by hand. But because consumers are not well informed about the merits of high-quality handmade artists' brushes, the quantities sold diminish every year, although such brushes are often the best all-around value.

Few of today's manufacturers are committed to preserving the traditional methods of manufacturing high-quality artists' brushes. Most are cutting back on production of the best varieties, concentrating instead on simpler and more profitable, mechanized production techniques. As a result, fewer new brushmakers are trained, and as the older artisans retire, they are not replaced. Traditional brushmaking thus is in danger of becoming a dying art. Consumer buying habits can do much to reverse this process and ensure that the more sophisticated professional-grade brushes will continue to be manufactured and made available.

Glossary

angular liner: A short, flat brush with a painting edge at a sharp angle to the straight edge formed by the opening of the ferrule. Angular liners are often made of white bristle and are used for sign painting.

bamboo brush: A Western expression used to describe round, pointed Oriental brushes.

belly: The thick midsection of a hair or of a tuft made from conic-shaped, pointed natural hair.

blenders: Any of several types of bushy oil-painting brushes originally used directly on the painting surface to blend paints of different colors.

brights: Short, flat, thin, square oil-painting brushes having a length out approximately equal to the width at the opening of the ferrule.

bristle: Hog hair.

brush head: That part of a brush comprising the tuft and the ferrule, exclusive of the handle.

brushstroke: The marks left by a brush on a painting surface.

butt: The root end of hair. Also, a hair that is upside down.

camel hair: A mixture of natural soft hairs that usually contains varying amounts of squirrel tail hair mixed with pony or other less expensive hairs.

caps: Protective plastic tubes that cover brush heads.

cat's tongues: Pointed filberts.

chiseled: Describing flat, thick, square brushes with staggered hairs that are held back along the sides in such a manner as to form tufts with the shape of a chisel.

Chungking bristles: Bristles from hogs that have been raised in the region of the Chinese city of Chungking.

civet cat: Any of several species of carnivorous mammals, the hair of which was once but is no longer used for making brushes.

crimping: The section of a metal ferrule that is compressed into the handle, serving to fasten and lock the brush heads onto the handle.

cups: Small brass brushmaker's molds having hollow interiors that correspond in shape to the form of the different brush styles, which are used to transform bundles of hair into the finished tufts.

cutters: Large flat brushes that resemble industrial-type paint brushes but that are of artists' brush quality; used for sign and bulletin painting.

dagger stripers: Brushes used to paint stripes on coaches and automobiles. They have long, flat, pointed tufts resembling the blade of a hunting knife and handles resembling daggers. The best are made of pure Russian squirrel hair.

deerfoot stipplers: Short, stubby brushes with round ferrules, and flat tops constructed at an angle, thereby having the shape of a deer's hoof. They are used primarily for ceramic and porcelain painting. The best are made of fitch tail hair.

diameter: The diameter of a brush is measured at the opening of the ferrule and corresponds to the dimensions at the inside of the ferrule.

double-drawn: Describing second-cut hairs that have been sectioned from the base of longer hairs. Double-drawn hairs do not have natural points, tips, or flags.

egberts: Extra-long filberts.

English sizes: A British system of brush sizes based on the numerical sizes of 3/0 through 12, odd numbers included.

entreplumes: French term for large brushes with natural quill ferrules composed of several pieces of quill wrapped around the tuft and wired together, as opposed to one seamless natural quill tube.

fans: Blending brushes that have large fan-shaped tufts. Also called fan blenders.

fashion quills: Round sable quill brushes that have very long, tapered points containing as many as five different hair lengths; at one time they were very popular for fashion illustration.

ferrule: The metal section of a brush into which the tuft is glued, which is then fastened to the handle.

filberts: Brushes with flattened ferrules and flat oval-shaped tufts.

fitch: A weasellike animal, closely related to the ferret, found throughout Europe and Asia. Also known as polecat. Its hair is used for high-quality artists' brushes.

Also, flat sign-painting brush with a tuft that protrudes from the large end of an inverted conic-shaped ferrule and a relatively small handle protruding from the small end of the ferrule.

flag: The naturally split ends of hog bristles.

flats: Long, flat oil-painting brushes that have square tips and a length out equal to approximately twice the width at the ferrule.

French sizes: A French system of brush sizes based on the numerical sizes 2 to 24, even numbers only. French sizes are smaller in diameter and length out than English sizes.

gilders' tips: Large, flat, thin soft-hair brushes used for applying gold leaf. The best are made of pure Russian squirrel hair.

graduated sizes: A series of brushes in which the length out increases as the numerical size and diameter increase.

gumming: A solution of gum arabic applied to tufts, which dries hard and serves to protect them from possible damage.

hair: Thin, soft hairs, as opposed to hog bristles or various types of thicker natural and synthetic fibers.

hand-cupped: Denoting brushes that have handmade tufts.

imprinting: The text or other markings printed on brush handles.

interlocked: Describes white bristle brushes made with bristles that curve inward toward the center of the tuft.

Kazan: Brown Russian squirrel tail hair.

kolinsky: A species of Asiatic mink, native to northeastern China and Siberia, the hair of which is used to make the finest soft-hair brushes.

length out: The length of a tuft, measured from the opening of the ferrule to the very end or point of the tuft.

meloncillo: Mongoose hair.

mixture: Bundles or tufts that contain two or more different types of hair, regardless of percentages.

mongoose: A small carnivorous mammal, native to India, the hair of which is used for brushes.

mops: Large, round, dome-shaped soft-hair brushes, used primarily as watercolor wash brushes.

mottlers: Large, flat, thin soft-hair brushes, often containing mixtures marketed as camel hair; however, the best are made of pure Russian squirrel.

nylon: Strong, elastic synthetic material that is fashioned into fibers and used for brushes.

ox hair: Hair taken from inside the ears of cattle and used in brushes.

pen brushes: Round pointed brushes used for calligraphy.

pony: Horse-body hair.

putois: French for fitch.

quills: Brushes that have natural bird-quill ferrules instead of metal ferrules.

repique: French term for very short, stubby, pointed brushes used primarily for retouching, spotting, and miniature painting.

roots: The bases of hairs and of tufts, as opposed to the points or tips.

rounds: Brushes with round ferrules and round oval-shaped tufts.

Royal Sable, Royal Crown Sable: Marketing name given to mongoose hair by certain manufacturers.

sabeline: Imitation sable hair, usually made by bleaching light ox hair, then dying it a red-brown color so as to resemble sable hair.

sable: Weasel tail hair (red sable) or kolinsky tail hair.

Sacamena: Blue-black Russian squirrel tail hair.

script-liners: Long, round, pointed brushes, used primarily for script lettering and line work.

shorts: Hairs that are too short to reach the glue in the ferrule, which then shed from the tuft.

single-stroke, one-stroke brushes: Large lettering brushes with flattened ferrules and square tips, designed to be used for painting large block letters with a single stroke of the brush.

sizes: The size numbers imprinted on brush handles.

snap: The degree of resiliency of a brush, as evidenced by the snapping noise made by the tuft when bent firmly to the side and then suddenly released.

solid: Describes bundles of hair containing hairs that are of equal length.

spotters, spotting brushes: Extra-small, round, pointed sable brushes used for very fine detail work.

squirrel: A small rodent found throughout the world, the tail hair of which is used for fine-quality brushes. Russian and Canadian squirrel tail hair are most commonly used.

stacking: A method of brush construction resulting in tufts with two or more different hair lengths.

stripers: Brushes used for painting stripes on automobiles, trucks, models, and porcelain.

synthetic hairs: Very thin synthetic fibers similar in diameter to natural soft hairs, as opposed to synthetic fibers of large diameter that resemble hog bristles.

Talahoutky, or Talaoutky: Gray Russian squirrel tail hair.

tapered: Describes bundles of hair containing hairs of two or more different lengths.

tops: The percentage of flagged bristles of equal length contained in bundles of hog bristles. The best grades are 90 percent tops, whereas inferior grades are only 50 percent tops.

Toray hair: Pointed synthetic hair that is available in several different diameters and in a number of colors.

truck-lettering brushes: Extra-long lettering brushes with flattened ferrules and square tips, used for painting large block letters on trucks, coaches, and other smooth surfaces.

tuft: The hair or bristle section of a brush, exclusive of the ferrule and the handle.

two-knot brush: A special interlocked white bristle oil-painting brush containing two individually tied tufts of curved bristles that are inserted into a single ferrule and flattened, giving the impression of a single tuft.

wash brushes: Large soft-hair brushes of varying shapes, used for watercolor wash work.

Index